MAXFIELD PARRISH

MAXFIELD PARRISH July 25, 1870 - March 30, 1966

THE MAXFIELD PARRISH

Identification & Price Guide

Second Edition

BY ERWIN FLACKS

Copyright © 1995 Collectors Press

All rights reserved. No part of this book may be reproduced or transmitted in any form or by any means, electronic or mechanical, including photocopying, recording, or by any information storage and retrieval system, without permission in writing from the publisher.

Second Edition, 1995

Printed in the United States of America 5 4 3 2 1

ISBN 0-9635202-2-9 : \$19.95 Library of Congress CCN 94-070638

The landscape and winter scenes were originally published by Brown & Bigelow, Inc.

Additional copies of this book may be purchased by sending \$19.95 plus \$2.50 shipping to:

Collectors Press P.O. Box 230986 Portland, OR 97281

VISA/MasterCard call (503) 684-3030

Acknowledgements 7 Introduction 9 Market Review The Environment 21 Reproductions 23 New Reproductions 27 Prints 33 Edison Mazda Calendars Brown & Bigelow Landscape Calendars Brown & Bigelow Winter Calendars Illustrated Books Illustrated Magazines 115 Posters & Advertisements Illustrated Programs & Related Miscellaneous Magazines & Calendars 217 Miscellaneous Spin-offs 233 Index 259

Dedicated to my wife and best friend, Gail, who urged me to undertake this book, assuring me that I could.

ACKNOWLEDGMENTS

Thanks go to Richard J. Perry for all of the material he researched and left to me from the first edition.

I would also like to thank Marc Mapelli and Richard Eubanks who assisted in keeping me straight on prices.

With much gratitude I wish to thank the following individuals for their contribution over the years:

Maxfield Parrish Jr., Jean Parrish, Coy Ludwig, Harold Knox, Alma Gilbert, Les Allen Ferry, Judy Goffman, Rosalind Wells, Jack Phillips, John Goodspeed Stuart. Special thanks go to widely recognized collector Denis C. Jackson, editor of "The Illustrator Collector's News". A sample copy of his publication may be purchased by sending \$3.50 to POB 1958, Sequim, WA 98382. Thanks to Paul Skeeters, author of *Maxfield Parrish*, *The Early Years*, who spent many happy days photographing my collection for his book.

And of course, a very special thanks to Maxfield Parrish.

PHOTOGRAPHS

The photographs in this guide were obtained from a variety of sources throughout the United States. The photographic skills, types of camera and lighting conditions varied greatly. In some cases, illustrations and photographs available were not of the highest caliber, but we chose to include them anyway for the purpose of identification. If you have material or information that is not already in this guide that you feel should be, the author would be happy to consider it for a future edition. Correspondences to the author may be made in care of the publisher at the address on the copyright page.

"Probably that which has a stronger hold on me than any other quality is color. I feel it is a language but little understood; much less so than what it used to be. To be a great colorist - that is my modest ambition. I hope someday to express the child's attitude towards nature and things; for this is the purest and most unconscious. For after we have 'gone through it all' we seem to come back again some day to our first impressions, with just a bit of worldly experience thrown in to make us conscious how delightful they are."

MAXFIELD PARRISH

INTRODUCTION

Maxfield Parrish is one of the most widely recognized names in American art history. His unique abilities and diversity of subject matter kept him employed for nearly seventy years as a painter and illustrator of children's books, advertising posters, programs, and murals, to name only a few. The most prosperous achievements of his lengthy career, however, were the illustrated covers and advertisements he painted for more than one hundred magazine companies. Many of these illustrations, and those of the children's books, were reproduced and sold individually. It was these "art prints" that, during much of the Art Noveau period, could be found quite frequently decorating homes throughout the United States.

It is easy to see why the work of Maxfield Parrish was so popular. Children and adults alike enjoyed his book illustrations for their descriptive depiction of the characters and scenes in each story. They seemed to take one back to a time of never-never land where fantasy and romance abounded and everyday life was just an endless dream of happiness and adventure.

Much of Maxfield Parrish's early involvement with art was prompted by his father, Stephen Parrish, who, with his own notable artistic efforts, taught his son to view his surroundings with an analytical eye, focusing his attention on natural beauty, shapes, shadows and light.

During his mid teens, Parrish sailed to Europe with his parents, where he was further influenced by the grand architecture and elaborate gardens of Italy, France and England. This experience was thought to have inspired him to become an architect but, after three

years of schooling in the subject, he changed his educational course to that of an artist. His architectural education did not prove useless, though; in fact, it gave him the core from which his talents grew.

At the age of twenty-six, he began illustrating his first book, "Mother Goose in Prose," which was published the following year, in 1897. This was the first of several books he illustrated, the last being "The Knave of Hearts," published in 1925. This book, in particular, is an excellent example of Parrish's artistic world of humor, fantasy and romance.

Parrish primarily illustrated magazines, but most of his widespread recognition was found in the art prints that were reproduced from such paintings as "Daybreak," "Stars," and "Dreaming." These examples, along with his many others of the Art Nouveau period, remain popular even through the everchanging popularity of art styles. His works of this period may lend some insight to the reason behind his enduring place in American art history.

One of the more notable achievements of Parrish's career was the calendar tops he painted for the Edison Mazda Lamp Division of General Electric. He was commissioned to paint one calendar a year from 1918 to 1934. Each calendar emphasized the environment and the various effects that light had upon it. Many consider that these calendars are the artist's finest work and best exemplify his use of rich color and light. After the 1934 calendar, "Moonlight," it becomes clear, in a letter from Parrish to Brown & Bigelow dated January 22, 1934, that change was inevitable. Parrish says he wants to "get away from the tiresome, contemplative figure on a rock....I think a change is good for everyone once in awhile." As this era came to an end, so the next began. From this point forward, Parrish changed his style and from then on focused almost exclusively on nature as his primary subject.

During the Edison Mazda era, Parrish was contacted numerous times by Brown & Bigelow of Saint Paul, Minnesota. In a letter from them dated December 17, 1929, they quote "We would like to have you do a subject for us.... If we should be fortunate enough, ...we would want to use your painting for calendar purposes." Because Parrish was always busy, he turned down commissions regularly, selecting only those which appealed to him the most. Money was

not his main concern nor sole motivation. Many times, upon completion of a job for a client with whom Parrish had an established relationship, he would want his recipient to simply pay him what they could afford at that time.

It was not until approximately one year after the Edison Mazda series was done, that Parrish decided to paint a series of landscape scenes for Brown & Bigelow which they printed onto calendars. These commissioned paintings came at a time when Parrish wanted a change, and this kind of work in particular was precisely what he was looking for.

His paintings were received with great praise and admiration from Brown & Bigelow. The public felt the same, and the calendar series sold so well that he continued to paint them for nearly thirty more years. They were sold in a variety of sizes to accommodate a demanding market. Greeting cards also were made, and sold well around the holidays.

In 1941, Parrish began painting a series of winter scenes for greeting cards and calendars that lasted until 1962, but, unlike the other landscapes, winter scenes were offered in only one calendar size for each year. The landscapes and winter scenes that Parrish painted were a direct reflection of his love of the outdoors as evidenced by his long-time residence in Plainfield, New Hampshire, where he used his local surroundings as his subject.

His home, "The Oaks," which he designed and built, was in itself a work of art and a direct reflection of his early architectural interest. His design included many secret passageways and variously-sized staircases. The house boasted a large "ballroom" and a living room with a stage. The woodwork inside the house was all painted blue and directly reflected his love of this hue, as evidenced in so many of his paintings. This color came to be known as "Parrish Blue."

As might be inferred from his paintings, he was very fond of children. He saw his own children daily at afternoon tea, and was totally engaged with the family when he was with them. His devotion to his family was paralleled by his total involvement with his art when he painted. He allowed no-one to watch him working, and ate all his meals, except for tea, alone.

A private person, he disliked reporters and having his photograph taken, but his stature as an artist grew such that he had to have

12 Introduction

dealings with the press.

After a long and highly successful career, Maxfield Parrish died at his home in Plainfield in 1966 at the age of ninety-five. Unlike most artists, he was fortunate enough to see his art grow in popularity and himself come to fame as a great American artist.

Parrish in his early 20s

Parrish at age 50

Aerial view of Parrish's home, "The Oaks," late fall 1936

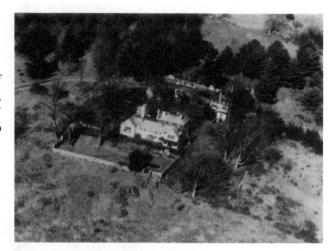

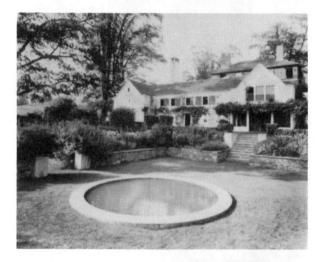

View of the south grounds at "The Oaks" 1940

Studio living room at "The Oaks" 1940

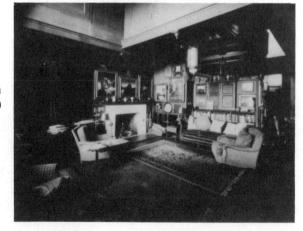

One of the many self-portraits Parrish took to reveal expressions, shadows and the natural way clothing drapes around the human figure.

This self-portrait was used to paint the Life Magazine cover for July 20, 1922. Often Parrish would shoot the photo by tying a string from his foot to the camera shutter.

Sketch with water colors done by Parrish at about age 12.

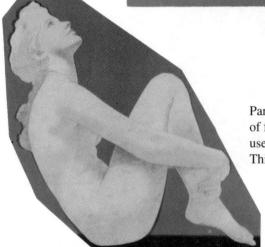

Parrish often made cut-outs of figures which he would use to paint the original. This one was used for "Stars".

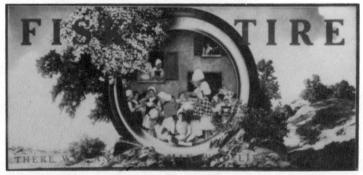

Fisk Tire Ad. "There was an old woman who lived in a shoe". This was a rare case when the preliminary sketch was approved, but the final oil painting was not. In a letter from Parrish to Fisk dated 1/27/22 he is quoted, "The change you request would be folly...to change the thing...would be more work than to make a new one...it would be cheaper to pay you back."

Windson: Vermont.

Valy 11th: 1903.

My dear Mr. Bok:

I have just returned and found your letter of July & the I should like To have a try at the cover Competition, and you may use my named in connection the with I have just seen Seribuero about the Field pictures and not decided to have them Just here to me if you will be so good, because I want to make a few changes before they publish them, and there is a damaged picture to fix, is there not?

Sweerely.

Maxfield Parish

THE LADIES HOME JOURNAL

Letter from Parrish

accepting the challenge

of a cover competition

for Ladies' Home Journal.

May 5, 1904.

My dear Parrish:

to tell you that your design, Toutlee in the Air," for our Dever Competition has been swarded the first prize, One Thousand Delhars. Check for this amount will no to you in due time. Fersonally, I am entirely estaffed with this descision, and I am ours you will not queriel with it. Your beautiful drawing has been admired by every one she has soon it, and we feel that in lawing the opportunity to publish it, we are subjects for competituations as well as worrest.

Mr. Set asked as to extend his contend his continal good whenes, and suspects that you write about a hundred and fifty words of description, which we will publish in consection with the drawing. The other winewars in order of source were, Miss Jesuin Willow Botth, Nrv. Alico Barther Stephenes, Mr. Marrison Pister and Miss Ide Wamphe.

Kindly let me hear from you, and

Yery electroly yours,

Mr. Maxfield Parrish, Windsor, Vermont. Letter from Ladies' Home Journal to Parrish informing him of being awarded first prize for his entry of "Castles in the Air" (Air Castles)

Personal letter from Parrish to Harrison Fisher informing him that all the drawings for Golden Age had been sold.

Parrish's photo of his models for an untitled over the mantel, mural in oil, 1920, measuring 3'5" X 7'10"

MARKET REVIEW

Up until now, identifying the works of Maxfield Parrish would require the ownership of several new and old books that have themselves become valuable and increasingly harder to find. This guide offers not only an extremely wide scope of illustrations for identification, but also presents a complete and accurate listing of their current market value. Many combined years of experience and research were brought together to bring you this most complete guide. You may use it with confidence when you are buying, selling, or just want to know what your pieces are currently worth.

You will see that there are high and low values placed on almost every piece listed. Both figures represent "mint condition" and assuming that with prints, they are in their undamaged, period frames. It was necessary to show both values because of regional price differences throughout the United States. The national average falls between the two. It could very well be that in your region, most of Parrish's work could be commanding the high price. It has been found that the West coast, and especially California, has been consistently commanding the highest national prices, and comes recommended as a good place to sell Parrish.

In cases where a piece is rarely seen and is in mint condition, you could expect to see anywhere from a 10 to 50 percent increase in price above what is listed in this guide. Generally, the narrower the gap between the high and low values, the more established the price is. Such a piece is most commonly found within the same general price range throughout the United States.

In purchasing a Parrish, damage to the piece can lower the price

listed. For the more commonly available pieces, damage might make you consider twice before you purchase. However, if the piece is scarce, but is damaged, you may want to buy it anyway, rather than not own it at all. Posters are an excellent example of this. They were made in relatively small numbers and often discarded after the event or purpose was accomplished. Keep in mind that if you purchase a piece in other than mint condition, you may be able to acquire one in better condition at a later date.

There will always be cases where people will pay more or less than what is listed in this guide. It is important to emphasize that this is a guide and should be used only as a guide. It is also important to note that a dealer purchasing a Parrish for resale will obviously want to make a profit as they are in business. Some of these dealers may want to double their money, and some will be happy with substantially less. To get the most for your piece, advertising it in a local newspaper or a national antique or art publication may be your best choice. Advertising locally, however, means having people in your home who you do not know. Advertising nationally means careful packaging and shipping on your part as well as guaranteeing that the recipient can return the piece if not satisfied for any reason.

As you can see, there are benefits and drawbacks to most methods of selling. The most desirable way that I have found, is to sell to, or possibly trade with, a fellow collector. If you do not know any, then one of the other described alternatives may be appropriate.

THE ENVIRONMENT

The environment into which paper has been placed and the time it has spent there can modify or accelerate the aging process. One or several of the following conditions can bring about the slow, natural deterioration of paper and colors: humidity, temperature, light and air. Understanding how paper is affected by its environment can help reveal the conditions in which the piece was kept, and what corrective changes, if any, need to be made.

Paper is a hygroscopic substance and, as such, it has a natural tendency to absorb water from the atmosphere. This quality enables it to be flexible and supple. This is why museums of fine art are humidity-controlled. Ideal humidity is between 45 to 55 percent at a temperature of 68 degrees Fahrenheit with a tolerable variance of 5 to 10 degrees. Air conditioners, humidifiers or dehumidifiers can effectively establish a suitable atmospheric condition for art printed on paper.

When there is insufficient humidity, paper will become stiff and brittle. Prolonged exposure to this condition can destroy the paper. If this condition is not too advanced, the paper can regain its suppleness when it is moved into the correct atmosphere. If damage is serious or permanent, it will be necessary to reinforce the piece with patches or a lining of paper.

Excessive humidity can soften paper, causing it to expand and change shape. Crinkles, warping, bulges and waves become excessively pronounced if the dampness is unevenly spread. Placing the paper in the correct environment can help to restore it, but if the paper is excessively distorted, pressing it out may improve its appearance. There are many methods of doing this, none of which is sure to give you perfect results. Because there are so many opinions

on this subject and so many different kinds of paper, we recommend that you contact a professional conservator for advice.

During the original framing process and other periods when the paper itself was handled, oils and grease from hands and from the air may have settled on the paper. Years may pass before the paper is placed in an unfavorable environment. Humidity and temperature can cause these micro-organisms to become active and spread, revealing themselves to the naked eye. Their appearance is of small brownish-grey to black spots dispersed unevenly throughout the paper. In more extreme situations, these dots will tend to group together and permanently damage the paper.

Air acts as a vehicle for dust, spores, and bacteria. It also activates the chemical components in paper. These pollutants can catalyze the impurities in paper and transform them into acids that can destroy the cellulose fibers in the paper.

Air also carries greasy dust, ash and other particles which lodge in the pores of paper and then darken its surface, often forming stains that are not removable. Soaking the paper in a water bath with a trace of mild soap, such as Ivory, can often remove this type of stain, but it softens the paper, making it susceptible to tearing. There are mixed opinions as to what chemicals to use or not use when soaking, the amount of time to soak the paper, and techniques for drying. It is always best to consult a professional conservator rather than experiment on your own. You could easily end up making the situation worse, or even destroying your work of art.

Obviously, light is necessary for the enjoyment of your piece; it is, nonetheless, a notorious enemy of paper. Both natural and artificial light emit radiation that is damaging to paper. It is the photochemical reaction of these rays with the impurities in paper that causes a breakdown of the cellulose fibers; causing colors to become bleached or yellowed. Many colors fade when exposed to light, causing irreparable damage. For this reason, it is important to limit the amount and duration of light used for display and examination.

Underexposure to light, in combination with humidity and inadequate ventilation, on the other hand, can create conditions in which micro-organisms and small insects can thrive. As you can see, the environment plays a large role in the condition of paper and can directly affect its longevity and value.

REPRODUCTIONS

The word "reproduction" in Parrish collecting frequently means new or fake or just not of the period from which the original was painted. Since original oils are not bought and sold in nearly the numbers that prints and other items are, the word "original" gets altered into meaning a "period piece" or printed during the period from which the original was painted. We will refer to a reproduction as either a "new reproduction" or an "original reproduction" (from the period in which the oil was painted). It seems that as we see more and more new reproductions on the market, those two words "reproduction" and "original" become increasingly distanced from their true meanings.

The existence of these later reproductions can cause problems for the unsuspecting or uninformed buyer. For those who do not have a preference between the two, a much less expensive new reproduction may be suitable and certainly more affordable. The following section is based upon the experiences of collectors and dealers who have learned, sometimes the expensive way, how to distinguish a new reproduction from an old one. The following will not make you an expert, but it will give you a better understanding of the fraudulent activities that exist and possibly help prevent a costly mistake.

Since the 1960s there has been a steady renewal of interest in the work of Maxfield Parrish. New reproductions are appearing more frequently, and the old ones are becoming more sought after. Thirty years later, reproductions of his work are still being made, and with the increasing value of his original prints, the market for the less expensive, new reproductions is larger than ever.

The evolution of the printing process has made it more difficult to distinguish a new reproduction from an old one. As a result, parties may sell new reproductions as old ones without even knowing the difference themselves. In other cases, the seller may have purchased the new reproduction by mistake and now wants to recover the loss. Still another circumstance is when a crafty individual who purchases a new reproduction, dips it in diluted coffee or tea, dries it in the sun for a few hours, then frames it in a period frame and tries, usually with good success, to sell it as an original. To complicate matters more, some will carefully peel back the old paper backing just enough to allow the removal of some of the nails and then lift the mat up, take the old print out and replace it with a new reproduction. The mat and nails are then put back and the old paper back reglued to the frame. Some even take the old paper backing from a larger frame, glue it to the back of the smaller reproduction's frame and then trim the edges to give it the appearance of an original. This is a very good reason never to assume that just because the paper backing is intact you have an original reproduction.

This situation is rarely found in a reputable shop but is more likely to occur in smaller auction houses where the description of the item is vague and the terms "bought as is, where is," and "you be the judge" apply. Careful examination during preview is essential. It is the surest way of avoiding buyer's remorse and unnecessary disputes after the auction is ended.

The term "original backing" and its effect on value and originality are often contradicting. Many Parrish collectors and dealers prefer to remove the old paper backing and cardboard matting and replace it with a fresh, clean rag board (acid-free matting) and new paper. A surprising number of them call the sole use of this rag board "museum framing" and use this term as an added tool for selling the art. Museum or conservation framing does involve the use of rag board, but it also incorporates linen or rice paper hinging, as well as matting. When matting is not desired, acid-free spacers are used to achieve the same purpose, which is to keep the piece away from the glass so that condensation does not form.

There are times when a piece should be reframed. The acids in the old wood pulp mat boards may be causing damage to the piece that is visible to the eye. It could also be necessary because moisture may have gotten inside at some point causing the mat to rot; then it may be just a matter of time before the piece gets damaged if it is not already.

There are claims that removing the original backing lowers the value of the piece and makes it somewhat more difficult to sell. Several reputable auction houses in the United States agree that even when they guarantee that the piece is original, it still does not bring bidding characteristic of that for original-backed prints. In fact, some of these auction houses will not even take on consignment reframed Parrish. If you are considering purchasing a reframed Parrish, you may want to ask why it was reframed and have the seller explain the method used.

Measuring a Parrish is one of the most important means of determining originality. The term "cropping" is used to describe a piece that has been cut down in size usually because damage existed around the edges. It also may have been cropped to fit a frame. Many times during the period in which the original reproductions were made, the purchaser might have a special frame to be used and would cut an art piece down to fit it. This is unfortunate but true and, in either case, cropping can greatly lower the value of a piece. If, when you measure a piece, it is smaller than what it should be, but the entire picture is there, you may have a reproduction. If the piece is larger than what it should be, you may likewise have a reproduction. There are occasions when the art may have been subject to moisture and temperature variations, in which case the piece may have contracted or expanded. For this substantially to affect the measurement, you will most likely see visible damage of the type described in this guide in the section on damage. In some cases, new prints are being made that will measure exactly the same as old ones. For this reason, you should never rely on just one or two criteria in making your decision as to authenticity.

New reproductions look new. Most of them are shiny with a surface appearance that looks similar to vinyl. Their colors are usually much more brilliant than those of the original reproduction. Details, as in the new poster books, look fuzzy in shaded areas and lack the same detail of the originals. Their color also has a kind of brassy look that is quite easy to identify once you have seen it.

Purchasing a poster book and a couple of new print or calendar reproductions is an excellent way to familiarize yourself with identifying new reproductions. Most of the antique shows and some of the publications will offer these for sale at substantially lower prices than those of the originals.

Another way of spotting a reproduction is by using a jeweler's loupe or a magnifying glass to see the dot pattern of the paper. This techique requires hands-on experience that can be gained by repetitious examination of the old in comparison with the new.

If you encounter a Parrish that is not in a frame, determining if it is an original is fairly easy. Old paper looks and feels old. The paper is generally heavier than what has been used over the past thirty years, and the back side is usually anywhere from a very light brown to dark brown. This is patina, a film that gradually appears on the surface from age. It will also occur on the front side, but on the back it is much easier to observe because it was usually white during the original printing. Cigarette smoke, wood burning stoves, fireplaces, and residual smoke and grease from cooking will also add to this discolorization. Generally, all prints fade to some degree. Looking at the piece printed side up, you will commonly see a border where the original or near-original color still exists. The severity of fading, however, may not be directly related to age. Much will depend upon the amount of light and length of time the print spent exposed to it.

Attending antique and collectible shows is an excellent place to see a variety of Parrish, and a great place to compare the new with the old. Take the opportunity to ask a lot of questions from the dealers who are selling his work. The honest Parrish dealers will be happy to engage in conversation with you as they, too, have a passion for the artist's work and want to help educate their market. After a while, identifying new reproductions will be easier, but just when you think you have it down, something new will come out of the woodwork; maybe a new printing method, or an aging technique not already known. Just remember to never assume. Always keep in mind the basics, carry this book with you, and don't be reluctant to ask as many questions as you like.

NEWER REPRODUCTIONS

With the continual advancement in printing technology, reproductions will look more and more authentic and will be made in sizes to match the old.

The following is a list of known titles of Parrish reproductions printed for mass marketing from the mid 1960s to the present.

Air Castles

Aladdin and the Wonderful Lamp

Apple Man
April Showers
An Ancient Tree

Arizona Atlas

The Botonist Canyon

Cadmus Sowing the Dragon's Teeth

Century Poster Cleopatra

Collier's Funnygraph
Columbia Bicycle Posters
Comic Scottish Soldier

Contentment

Crane Chocolate Ad

Dark Futurist Daybreak A Departure Dies Irae Dinkey Bird

Djer Kiss Ad - Girl on Swing

Dreaming Dreamlight Ecstasy Egypt

Enchantment
The End

Evening Shadows

The Fisherman and the Genie

Florentine Fete Frog Prince Garden of Allah The Glen

Golden Hours

Griselda (Enchantment)

Harvest Hilltop

Humpty Dumpty

The Idiot Interlude

Jason and His Teacher Jello Ad - King and Queen

Jello Ad - Polly

John Wanamaker Painter's Palette

King of the Black Isles

Knave Watches Lady Violetta Depart

Lampseller of Bagdad Land of Make-Believe

Lantern Bearers
Lute Players
Masquerade
Millpond
Misty Morn
Moonlight
Morning
Morning Light

New Moon
Old Glen Mill
The Palace Garden

Panel for the Florentine Fete

Peaceful Valley A Perfect Day Pied Piper Primitive Man The Prince
Prometheus
Queen Gulnare
Quiet Solitude
Reluctant Dragon

Reveries Romance Rubaiyat

Scribner's August Sheltering Oaks

Sinbad Plots Against the Giant

Snowdrop Solitude

Spirit of the Night

Spring Stars Tranquility Twilight

Under Summer Skies Venetian Lamplighter

Venetian Night's Entertainment

Waterfall White Birch

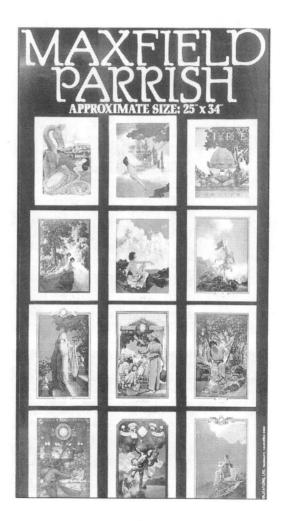

Early 1970s poster of reproductions. The poster itself is valued at \$75-\$95

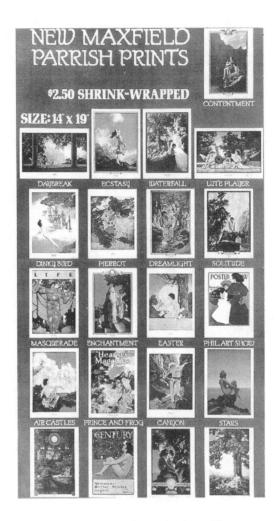

Early 1970s poster of reproductions. The poster itself is valued at \$75-\$95

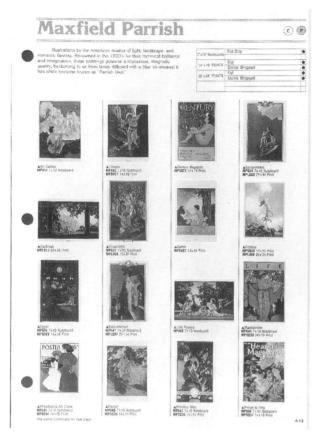

Contemporary page from a catalog offering Parrish reproductions.

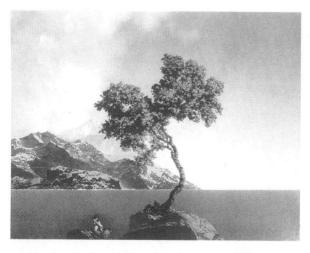

New reproduction (1993) - Limited Edition print "Aquamarine" 12 1/2" X 16" \$125

THE PRINTS

"There is a constant demand for pictures to be used as prints as it saves re-papering the wall's (sic) of young ladies' seminaries."

Maxfield Parrish February 1, 1922

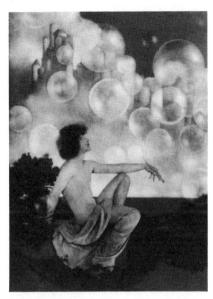

ALADDIN AND THE WONDERFUL LAMP 1907 From "The Arabian Nights" 9" X 11" / \$130-\$150 P.F. Collier & Son

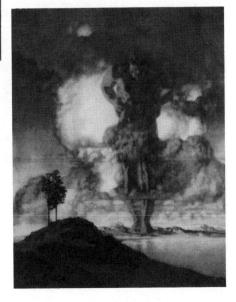

ATLAS 1908 From "A Wonderbook and Tanglewood Tales" 9 1/2" X 11 1/2" / \$150-\$175 P.F. Collier & Son

AUCASSIN SEEKS FOR NICOLETTE 1903 11 1/2" X 17" / \$450-\$495 Charles Scribner's Sons

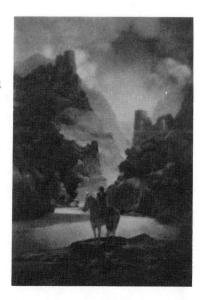

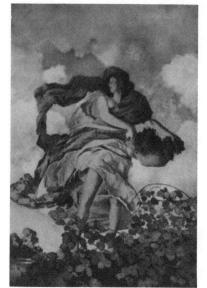

AUTUMN 1905 From "The Golden Treasury of Songs and Lyrics" 10" X 12" / \$175-\$225 P.F. Collier & Son

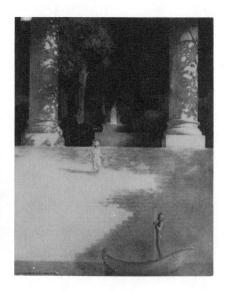

THE LANDING OF THE **BRAZEN BOATMAN** 1907 From "The Arabian Nights" 9" X 11" / \$140-\$160 P.F. Collier & Son

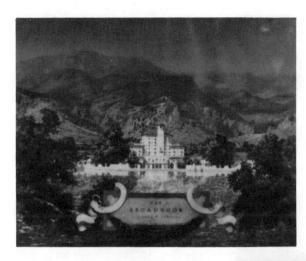

THE BROADMOOR 1921 6 3/4" X 8 1/2" / \$125-\$150 17 1/4" X 22" / \$450-\$495

CADMUS SOWING THE DRAGON'S TEETH

1909

From "A Wonderbook and Tanglewood Tales" 9 1/4" X 11 1/2" / \$130-\$150 P.F. Collier & Son

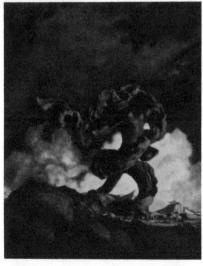

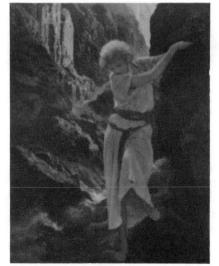

THE CANYON 1924 6" X 10" / \$120-\$135 12" X 15" / \$225-\$275 House of Art

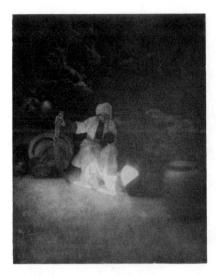

CASSIM 1906 From "The Arabian Nights" 9" X 11" / \$125-\$140 P.F. Collier & Son

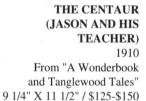

P.F. Collier & Son

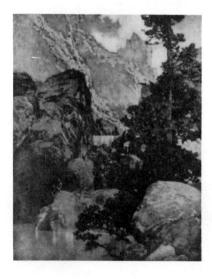

THE CHIMERA (BELLEROPHON) 1909 From "A Wonderbook and Tanglewood Tales" 9 1/4" X 11 1/2" / \$170-\$200 P.F. Collier & Son

CIRCE'S PALACE 1908 From "A Wonderbook and Tanglewood Tales" 9 1/4" X 11 1/2" / \$165-\$195

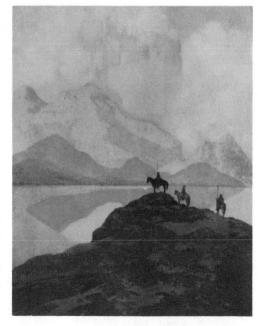

CITY OF BRASS 1905 From "The Arabian Nights" 9" X 11" / \$135-\$150 P.F. Collier & Son

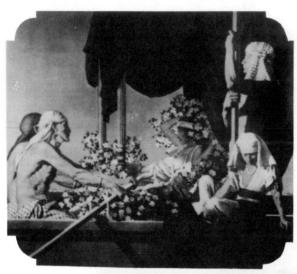

CLEOPATRA 1917 6 1/4" X 7" / \$200-\$250 13 1/2" X 15 1/2" / \$550-\$650 24 1/4" X 28" / \$1500-\$2000 House of Art

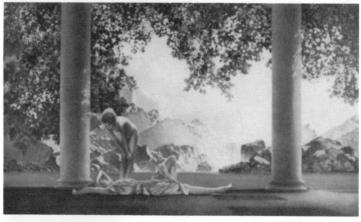

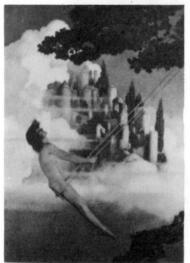

DAYBREAK 1923 6" X 10" / \$85-\$125 10" X 18" / \$185-\$245 18" X 30" / \$375-\$495 House of Art

THE DINKEY-BIRD 1905 From "Poems of Childhood" 11" X 16" / \$195-\$265 Charles Scribner's Sons

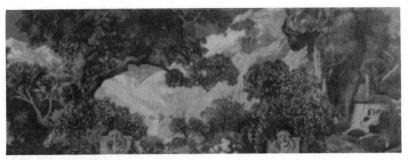

DREAM GARDEN 1915 14" X 24 1/2" / \$550-\$675 Curtis Publishing Company

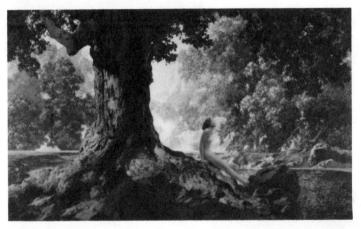

DREAMING 1928 6" X 10" / \$175-\$200 10" X 18" / \$375-\$425 18" X 30" / \$1100-\$1300 House of Art

EASTER 1905 From "The Golden Treasury of Songs and Lyrics" 8" X 10" / \$125-\$175 P.F. Collier and Son

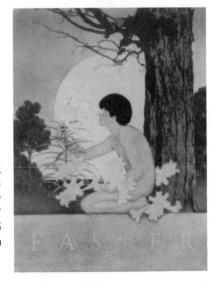

ERRANT PAN 1910 9" X 11" / \$175-\$225 Charles Scribner's Sons

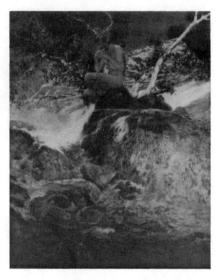

EVENING 1922 6" X 10" / \$110-\$150 12" X 15" / \$225-\$275 House of Art

THE FOUNTAIN OF PIRENE

From "A Wonderbook and Tanglewood Tales" 9 1/4" X 11 1/2" / \$170-\$200 Charles Scribner's Sons

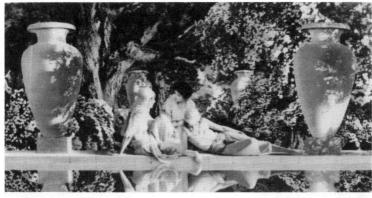

GARDEN OF ALLAH

1918 4 1/2" X 8" / \$75-\$95 9" X 18" / \$175-\$245 15" X 30" / \$350-\$425 House of Art

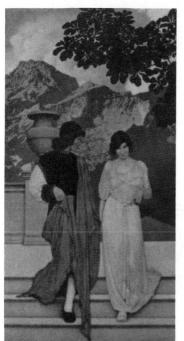

GARDEN OF OPPORTUNITY

1915 10 3/4" X 20 1/2" / \$425-\$500 Curtis Publishing Company

THE GARDENER 1907 13" X 19" / \$250-\$300 P.F. Collier & Son

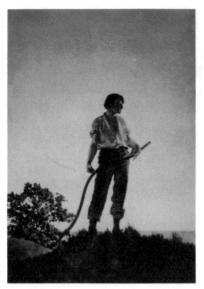

HARVEST 1905 From "The Golden Treasury of Songs and Lyrics" 8" X 10" / \$225-\$260 Dodge Publishing Company

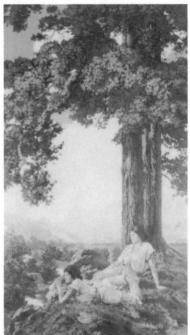

HISTORY OF THE FISHER-MAN AND THE GENIE 1906 From "The Arabian Nights" 9" X 11" / \$130-\$150 P.F. Collier & Son

THE IDIOT OR BOOKLOVER 1910 8" X 11" / \$220-\$260 P.F. Collier & Son

INTERLUDE 1924 (See "The Lute Players") 12" X 15" / \$300-\$350 House of Art

JACK FROST 1936 12 1/2" X 13" / \$250-\$325 P.F. Collier & Son

JASON AND THE TALKING OAK 1908 From "A Wonderbook

and Tanglewood Tales" 9 1/4" X 11 1/2" / \$125-\$150 P.F. Collier & Son

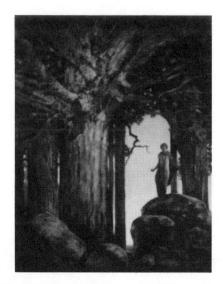

KING OF THE BLACK ISLES From "The Arabian Nights" 9" X 11" / \$125-\$145

P.F. Collier & Son

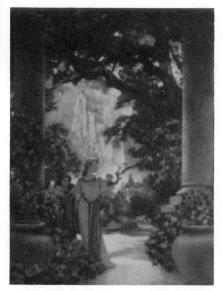

LAND OF MAKE-BELIEVE 1912 9" X 11" / \$225-\$250 Charles Scribner's Sons

THE LANTERN BEARERS From " The Golden Treasury of Songs and Lyrics" 9 1/2" X 11 1/2" / \$240-\$290 P.F. Collier & Son

THE LUTE PLAYERS 1924 (See "Interlude") 6" X 10" / \$125-\$150 10" X 18" / \$280-\$330 18" X 30" / \$650-\$800 House of Art

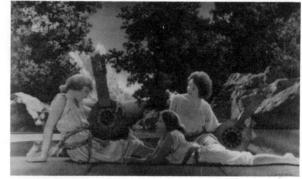

MORNING 1922 6" X 10" / \$100-\$120 12" X 15" / \$200-\$225 House of Art

THE NATURE LOVER 1911 10" X 13" / \$195-\$250 P.F. Collier & Son

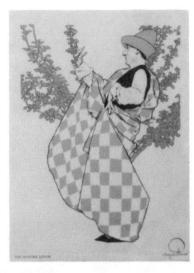

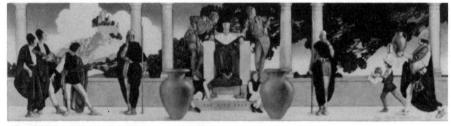

OLD KING COLE (ST. REGIS) 1906 3" X 11 1/2" / \$265-\$325 6 1/4" X 23" / \$950-\$1100 Dodge Publishing Company

THE PAGE 1925 From "The Knave of Hearts" 9 3/4" X 12" / \$200-\$250 House of Art

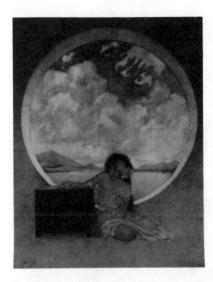

PANDORA 1909 From "A Wonderbook and Tanglewood Tales" 9" X 11" / \$125-\$160 P.F. Collier & Son

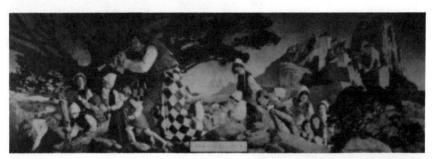

PIED PIPER 1909 6 3/4" X 21" / \$825-\$1000 P.F. Collier & Son

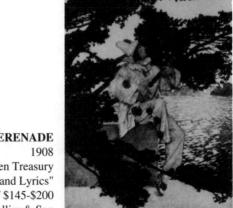

PIERROT'S SERENADE

From "The Golden Treasury of Songs and Lyrics" 9 1/2" X 11 1/4" / \$145-\$200 P.F. Collier & Son

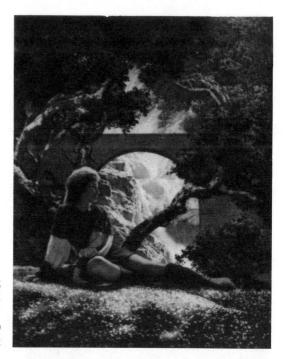

THE PRINCE 1925 From "The Knave of Hearts" 10" X 12" / \$200-\$250 House of Art

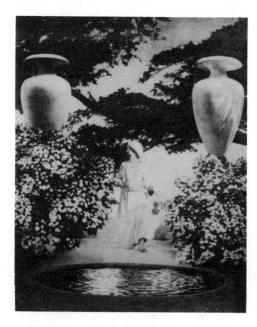

PRINCE AGIB (THE STORY OF A KING'S SON) 1906 From "The Arabian Nights" 9" X 11" / \$130-\$150 P.F. Collier & Son

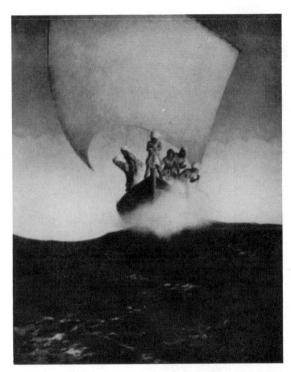

PRINCE CODADAD 1906 From "The Arabian Nights" 9" X 11" / \$130-\$160 P.F. Collier & Son

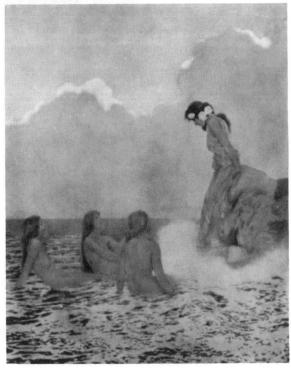

THE SEA NYMPHS 1910 From "A Wonderbook and Tanglewood Tales" 9 1/4" X 11 1/2" / \$125-\$160 P.F. Collier & Son

PROSERPINA AND

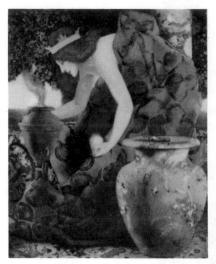

QUEEN GULNARE 1907 From "The Arabian Nights" 9" X 11" / \$125-\$160 P.F. Collier & Son

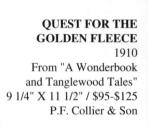

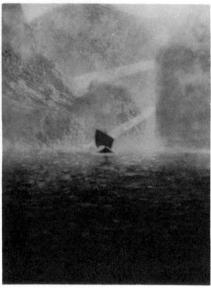

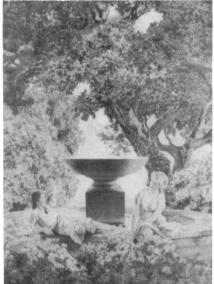

REVERIES OR GOLDEN REVERIES 1928 6" X 10" / \$100-\$130 12" X 15" / \$220-\$240

House of Art

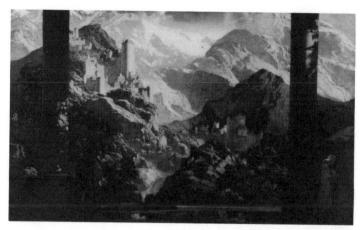

ROMANCE 1925 From "The Knave of Hearts" 23 1/2" X 14 1/4" / \$900-\$1100 House of Art

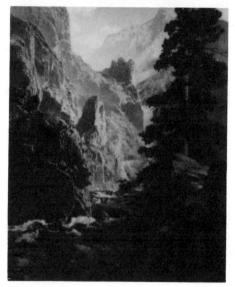

ROYAL GORGE OF THE COLORADO 1923 (Same as Spirit of Transportation without two small trucks on cliff) 16 1/2" X 20" / \$450-\$550

RUBAIYAT 1917 2" X 8 1/2" / \$95-\$125 3 3/4" X 14 3/4" / \$260-\$320 7" X 28 1/2" / \$575-\$650 House of Art

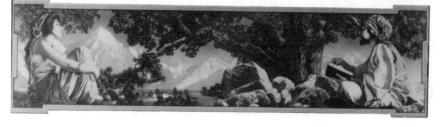

SEARCH FOR THE SINGING TREE 1906 From "The Arabian Nights" 9" X 11" / \$130-\$150 P.F. Collier & Son

SHOWER OF FRAGRANCE 1912 8 1/2" X 11" / \$240-\$270 Curtis Publishing Company

SINBAD PLOTS AGAINST THE GIANT 1907 From "The Arabian Nights" 9" X 11" / \$150-\$180 P.F. Collier & Son

SING A SONG OF SIXPENCE 1911 9" X 21" / \$850-\$1000 P.F. Collier & Son

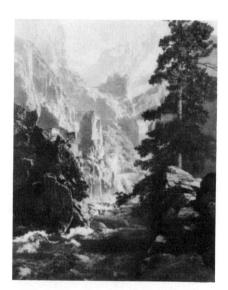

SPIRIT OF TRANSPORTATION
1923
(Same as Royal Gorge of the Colorado with addition of two small trucks on cliff)
16 1/2" X 20" / \$450-\$600

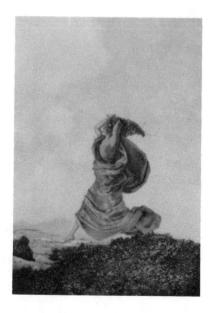

SPRING 1905 From "The Golden Treasury of Songs and Lyrics" 9 3/4" X 11 3/4" / \$130-\$160 P.F. Collier & Son

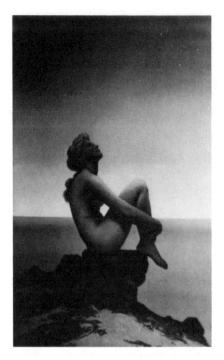

STARS 1927 6" X 10" / \$175-\$225 10" X 18" / \$450-\$600 18" X 30" / \$850-\$1200 House of Art

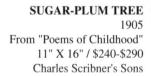

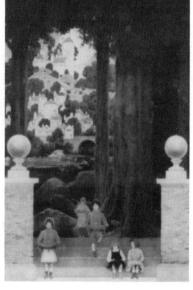

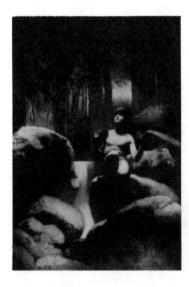

SUMMER 1905 From "The Golden Treasury of Songs and Lyrics" 11" X 16" / \$190-\$250 Charles Scribner's Sons

THE TEMPEST (AN ODD ANGLE OF THE ISLE) 1909 7" X 7" / \$130-\$160 P.F. Collier & Son

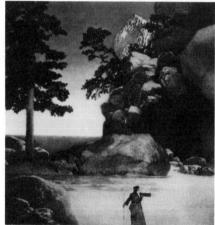

THE TEMPEST (PROSPERO AND HIS MAGIC) 1909 7" X 7" / \$130-\$160 P.F. Collier & Son

THE TEMPEST (THE PHOENIX THRONE) 7" X 7" / \$130-\$160 P.F. Collier & Son

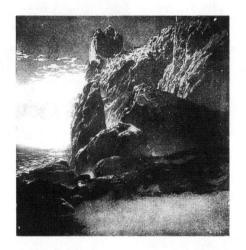

THE TEMPEST
(AS MORNING STEALS UPON THE NIGHT)
1909
7" X 7" / \$130-\$160
P.F. Collier & Son

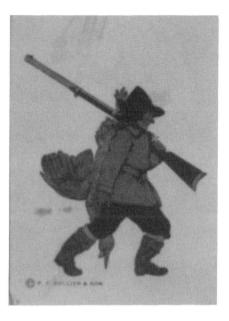

THANKSGIVING 9" X 11" / \$220-\$270 P.F. Collier & Son

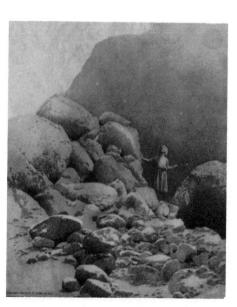

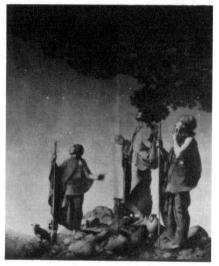

VALLEY OF DIAMONDS 1907 From "The Arabian Nights" 9" X 11" / \$130-\$160 P.F. Collier & Son

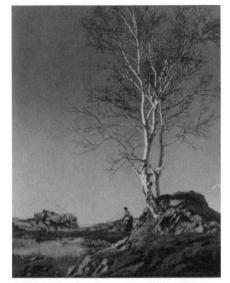

WHITE BIRCH 9" X 11 1/4" / \$100-\$120 House of Art

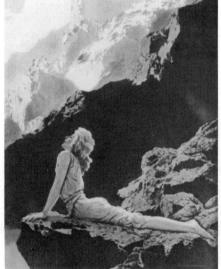

WILD GEESE 1924 11 3/4" X 14 3/4" / \$195-\$275 House of Art

WITH TRUMPET AND DRUM 1905 From "Poems of Childhood" 11 1/4" X 16 1/2" / \$270-\$340 Charles Scribner's Sons

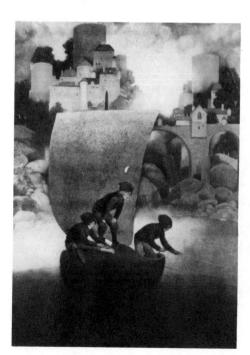

WYNKEN, BLYNKEN AND NOD 1905 From "Poems of Childhood" 10 1/4" X 14 1/2" / \$240-\$290 Charles Scribner's Sons

ITALIAN VILLAS AND THEIR GARDENS 1915

The Century Company

PRINTS MEASURE: 5" X 7 3/4" / \$60-\$80 EACH WITH MATS: 10 1/2" X 14" / \$70-\$100 EACH

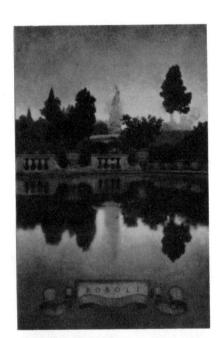

BOBOLI GARDEN

GARDEN OF ISOLA BELLA

POOL OF VILLA D'ESTE

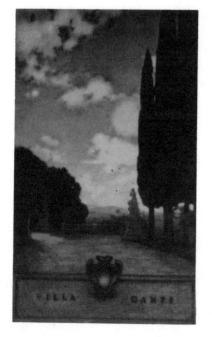

A Company of the comp

THEATRE AT LA PALAZZINA SIENA

VILLA CAMPI

VILLA CHIGI

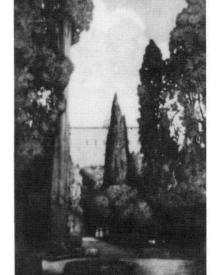

VILLA D'ESTE

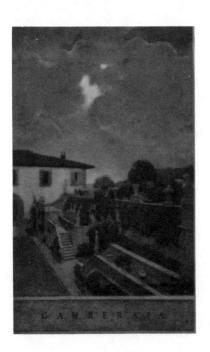

VILLA GAMBERAIA

VILLA GORI

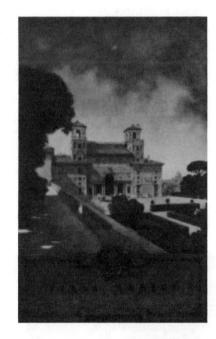

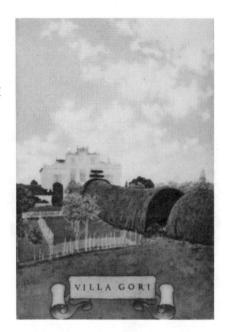

VILLA MEDICI

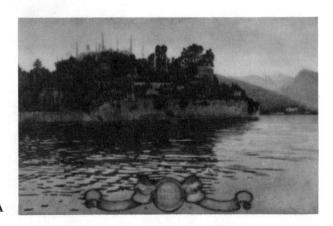

VILLA ISOLA BELLA

VILLA PLINIANA

VILLA SCASSI

THE EDISON MAZDA CALENDARS

"In a long series like these calendars it seems inevitable that in time an artist goes stale. You see it clearly in magazine covers painted by the same artist year after year: his or her work becomes a rubber stamp."

Maxfield Parrish January 22, 1934 Edison Mazda calendars fall into four main size groups for complete and cropped calendars. The measurements given below are averages from the series. A variance of approximately 1/2" on the small calendars and 1" on the large, can be expected from year to year. Refer to "Reproductions" chapter for further information concerning newer reproductions.

MEASUREMENTS

Large complete with full pad: 18" x 37 1/2" Small complete with full pad: 8 1/2" x 19"

Large cropped (with logo - 1st 7 years): 14 1/2" x 22 1/2" Small cropped (with logo - 1st 7 years): 6 1/4" x 10 1/2"

Cropped calendar tops without the logo visible (1st 7 years) are valued at 20% less than with the logo visible.

DAWN AND NIGHT IS FLED

1918

Large Complete: \$2300-\$3000 Small Complete: \$1250-\$1500 Large Cropped: \$1250-\$1500 Small Cropped: \$750-\$1000

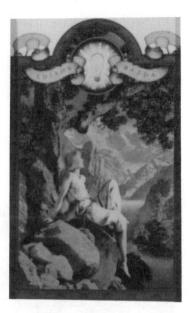

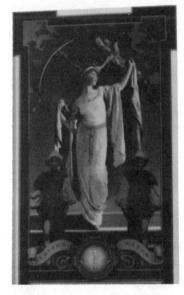

SPIRIT OF THE NIGHT

1919

Large Complete: \$2800-\$3500 Small Complete: \$1200-\$1500 Large Cropped: \$1250-\$1500 Small Cropped: \$750-\$1000

1920

Large Complete: \$2300-\$3000 Small Complete: \$1250-\$1500 Large Cropped: \$1250-\$1500 Small Cropped: \$750-\$1000

PRIMITIVE MAN

1921

Large Complete: \$2300-\$3000 Small Complete: \$1250-\$1500 Large Cropped: \$1250-\$1500 Small Cropped: \$750-\$1000

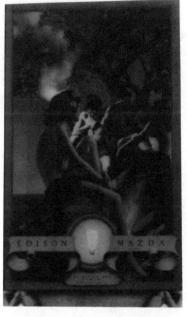

EGYPT 1922

Large Complete: \$2300-\$3000 Small Complete: \$1250-\$1500 Large Cropped: \$1250-\$1500 Small Cropped: \$750-\$1000

LAMP SELLER OF BAGDAD

1923

Large Complete: \$2200-\$2900 Small Complete: \$1150-\$1400 Large Cropped: \$1150-\$1400

Small Cropped: \$650-\$900

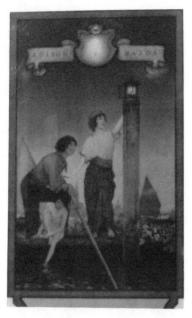

VENETIAN LAMPLIGHTER

1924

Large Complete: \$2200-\$2900 Small Complete: \$800-\$1000 Large Cropped: \$1150-\$1400 Small Cropped: \$325-\$400

DREAMLIGHT

1925

Large Complete: \$1850-\$2150 Small Complete: \$750-\$850 Large Cropped: \$900-\$1050 Small Cropped: \$325-\$400

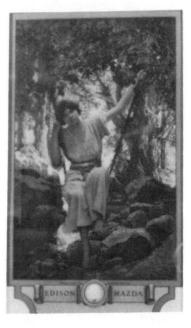

ENCHANTMENT

Large Complete: \$1850-\$2300 Small Complete: \$750-\$875 Large Cropped: \$1000-\$1250 Small Cropped: \$275-\$375

REVERIES

1927

Large Complete: \$1250-\$1450 Small Complete: \$450-\$550

Large Cropped: \$600-\$650 Small Cropped: \$175-\$200

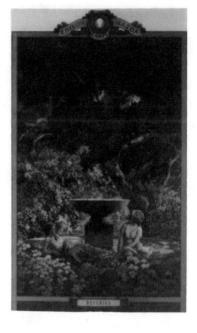

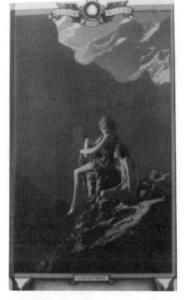

CONTENTMENT

1928

Large Complete: \$1550-\$1750 Small Complete: \$600-\$700 Large Cropped: \$750-\$900 Small Cropped: \$200-\$275

Large Complete: \$1250-\$1500 Small Complete: \$500-\$600 Large Cropped: \$600-\$700

Small Cropped: \$175-\$200

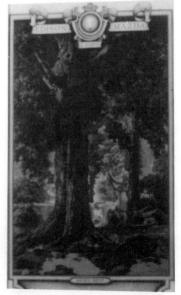

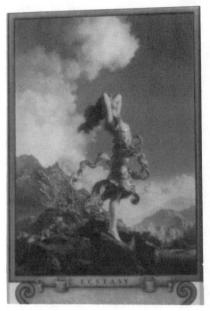

ECSTASY

1930

Large Complete: \$1650-\$2000 Small Complete: \$650-\$750 Large Cropped: \$800-\$1000 Small Cropped: \$250-\$325

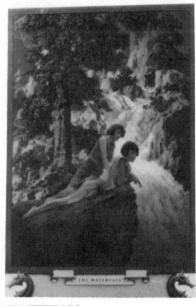

WATERFALL

1931

Large Complete: \$1650-\$2000 Small Complete: \$650-\$750 Large Cropped: \$800-\$1000 Small Cropped: \$250-\$325

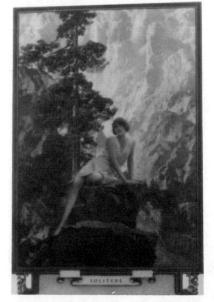

SOLITUDE

1932

Small Complete: \$700-\$850 Small Cropped: \$200-\$260

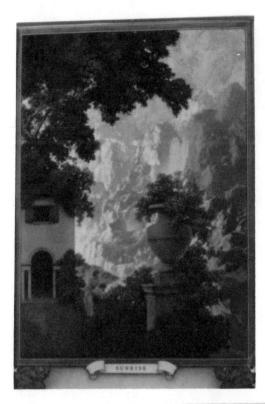

SUNRISE

1933

Large Complete: \$1800-\$2100 Small Complete: \$800-\$1100 Large Cropped: \$800-\$950 Small Cropped: \$225-\$260

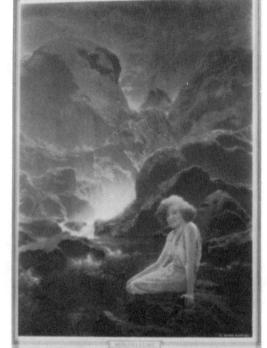

MOONLIGHT

1934

Small Complete: \$800-\$1100 Small Cropped: \$275-\$350

BROWN & BIGELOW LANDSCAPE CALENDARS

"I had much rather spend the rest of the time doing other things, like landscape, which I enjoy much more."

> Maxfield Parrish December 27, 1929

Brown and Bigelow landscape calendars are mostly referred to by the title given by the publisher. However, there are occasions when the artist's title may be used. Both titles have been listed when known (Parrish titles in parentheses).

The landscapes were printed in a variety of sizes for a diverse market. In recording the artwork, measurements were found to fall into five main groups. These groups shown below are the image or cropped size, and are the basis for the prices in this chapter. Refer to the "Reproductions" chapter for more information about newer reproductions and their measurements.

MEASUREMENTS

Miniature: 3 1/4" X 4"

X-Small: 4 1/2" X 6"

Small: 8" X 11"

Medium: 11" X 16" Large: 16 1/2" X 22"

X-Large: 24" X 30"

PEACEFUL VALLEY (TRANQUILITY)

1936	Complete	Cropped
Miniature	\$45-\$55	\$15-\$20
X-Small	\$65-\$75	\$20-\$25
Small	\$235-\$285	\$130-\$160
Medium	\$285-\$335	\$210-\$260
Large	\$410-\$500	\$285-\$335
X-Large	\$700-\$825	\$475-\$600

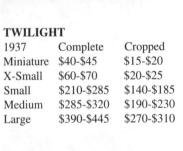

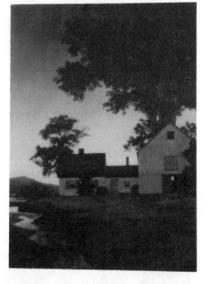

THE GLEN

1938	Complete	Cropped
Miniature	\$55-\$60	\$15-\$20
X-Small	\$75-\$85	\$25-\$30
Small	\$260-\$320	\$170-\$210
Medium	\$340-\$410	\$240-\$285
Large	\$525-\$600	\$365-\$415

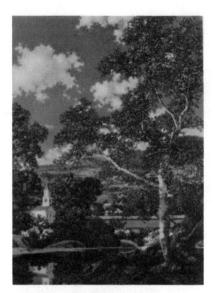

EARLY AUTUMN (AUTUMN BROOK)

1939	Complete	Cropped
Miniature	\$45-\$50	\$15-\$20
X-Small	\$65-\$80	\$20-\$25
Small	\$210-\$270	\$150-\$190
Medium	\$280-\$330	\$200-\$250
Large	\$420-\$510	\$300-\$345

(one biller little)		
1940	Complete	Cropped
Miniature	\$60-\$65	\$20-\$25
X-Small	\$75-\$85	\$25-\$30
Small	\$280-\$335	\$200-\$340
Medium	\$400-\$460	\$285-\$320
Large	\$570-\$670	\$395-\$445

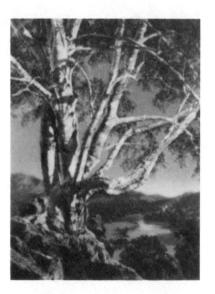

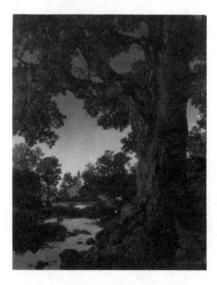

THE VILLAGE BROOK

1941	Complete	Cropped
Miniature	\$45-\$50	\$15-\$20
X-Small	\$65-\$75	\$20-\$25
Small	\$210-\$260	\$150-\$180
Medium	\$310-\$375	\$220-\$260
Large	\$470-\$540	\$320-\$370

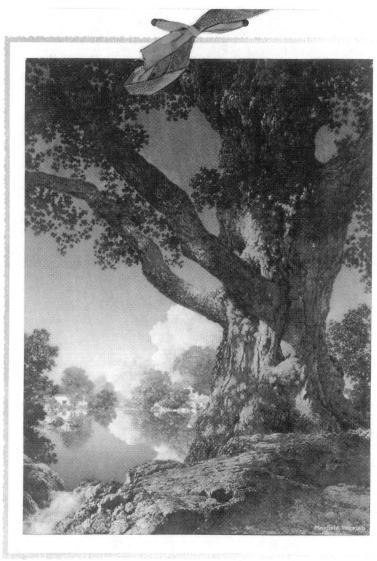

Example of a complete 1941 calendar

THY TEMPLED HILLS (NEW HAMPSHIRE: THE LAND OF SCENIC SPLENDOR)

1942	Complete	Cropped
Miniature	\$45-\$50	\$15-\$20
X-Small	\$60-\$75	\$20-\$25
Small	\$190-\$240	\$130-\$170
Medium	\$280-\$350	\$200-\$250
Large	\$420-\$510	\$300-\$350

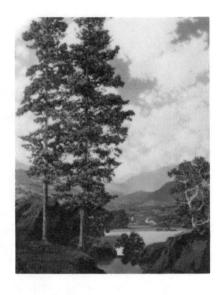

A PERFECT DAY (JUNE SKIES)

1943	Complete	Cropped
Miniature	\$45-\$50	\$15-\$20
X-Small	\$65-\$75	\$20-\$25
Small	\$210-\$270	\$150-\$190
Medium	\$300-\$360	\$220-\$275
Large	\$440-\$550	\$310-\$380

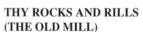

1944	Complete	Cropped
Miniature	\$45-\$50	\$15-\$20
X-Small	\$70-\$80	\$20-\$25
Small	\$225-\$290	\$160-\$200
Medium	\$330-\$390	\$240-\$275
Large	\$510-\$595	\$345-\$395

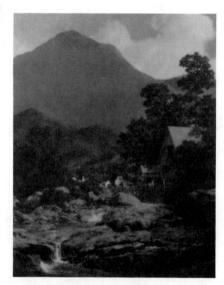

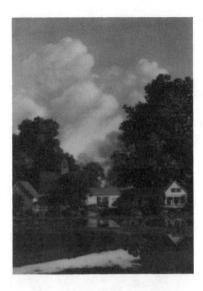

SUNUP (LITTLE BROOK FARM)

1945	Complete	Cropped
Miniature	\$40-\$45	\$10-\$15
X-Small	\$60-\$70	\$15-\$20
Small	\$210-\$260	\$150-\$190
Medium	\$290-\$350	\$200-\$260
Large	\$445-\$520	\$300-\$350

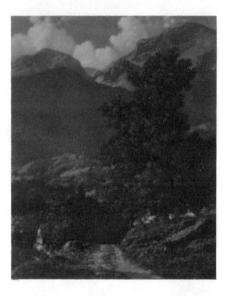

VALLEY OF ENCHANTMENT (ROAD TO THE VALLEY)

1946	Complete	Cropped
Miniature	\$45-\$50	\$15-\$20
X-Small	\$65-\$75	\$20-\$25
Small	\$240-\$280	\$170-\$200
Medium	\$320-\$370	\$235-\$270
Large	\$470-\$575	\$320-\$360

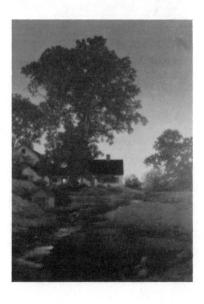

EVENING

Complete	Cropped
\$45-\$50	\$15-\$20
\$75-\$85	\$25-\$30
\$235-\$280	\$170-\$200
\$335-\$380	\$230-\$260
\$470-\$570	\$310-\$350
	\$45-\$50 \$75-\$85 \$235-\$280 \$335-\$380

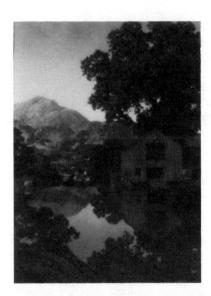

THE MILL POND

1948	Complete	Cropped
Miniature	\$55-\$70	\$20-\$25
X-Small	\$70-\$85	\$25-\$30
Small	\$270-\$335	\$190-\$235
Medium	\$380-\$460	\$270-\$320
Large	\$550-\$650	\$375-\$425

	OL CALCA	~~~
1949	Complete	Cropped
Miniature	\$45-\$50	\$15-\$20
X-Small	\$65-\$75	\$20-\$25
Small	\$220-\$260	\$150-\$180
Medium	\$300-\$360	\$210-\$250
Large	\$445-\$540	\$300-\$360

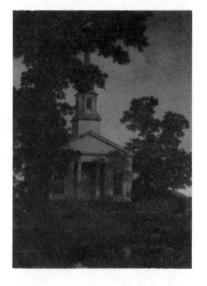

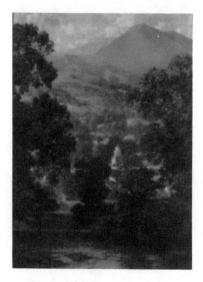

SUNLIT VALLEY

1950	Complete	Cropped
Miniature	\$50-\$55	\$20-\$25
X-Small	\$65-\$80	\$25-\$30
Small	\$240-\$300	\$170-\$220
Medium	\$320-\$390	\$230-\$285
Large	\$470-\$550	\$320-\$370

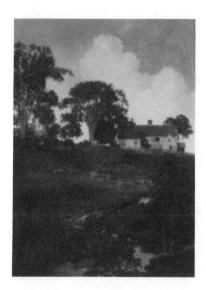

DAYBREAK (HUNT FARM)

Complete	Cropped
\$50-\$55	\$20-\$25
\$70-\$80	\$25-\$30
\$240-\$290	\$170-\$200
\$335-\$385	\$235-\$270
\$460-\$540	\$320-\$360
	\$50-\$55 \$70-\$80 \$240-\$290 \$335-\$385

1952	Complete	Cropped
Miniature	\$50-\$55	\$20-\$25
X-Small	\$65-\$75	\$25-\$30
Small	\$250-\$300	\$170-\$210
Medium	\$340-\$390	\$230-\$280
Large	\$470-\$545	\$320-\$370

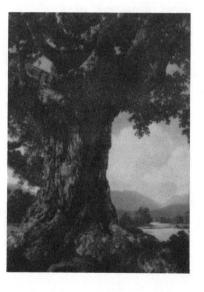

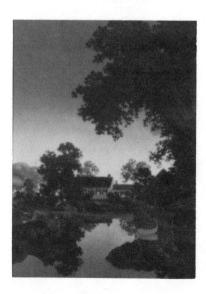

EVENING SHADOWS (PEACE OF EVENING)

Complete	Cropped
\$50-\$55	\$15-\$20
\$70-\$80	\$20-\$25
\$240-\$300	\$170-\$200
\$340-\$425	\$240-\$290
\$500-\$600	\$325-\$370
	\$50-\$55 \$70-\$80 \$240-\$300 \$340-\$425

THE OLD GLEN MILL (GLEN MILL)

1954	Complete	Cropped
Miniature	\$60-\$70	\$20-\$25
X-Small	\$85-\$95	\$25-\$35
Small	\$310-\$390	\$220-\$270
Medium	\$430-\$510	\$300-\$360
Large	\$600-\$700	\$400-\$475

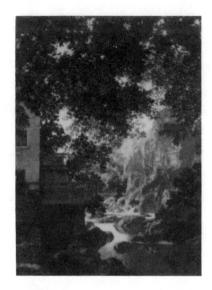

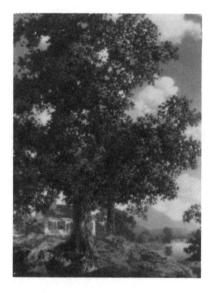

PEACEFUL VALLEY (HOMESTEAD)

1955	Complete	Cropped
Miniature	\$45-\$50	\$15-\$20
X-Small	\$65-\$75	\$20-\$25
Small	\$230-\$270	\$160-\$190
Medium	\$300-\$350	\$210-\$250
Large	\$420-\$485	\$285-\$320

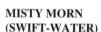

Complete	Cropped
\$50-\$55	\$15-\$20
\$65-\$80	\$20-\$25
\$260-\$310	\$185-\$220
\$350-\$410	\$250-\$285
\$510-\$570	\$340-\$370
	\$50-\$55 \$65-\$80 \$260-\$310 \$350-\$410

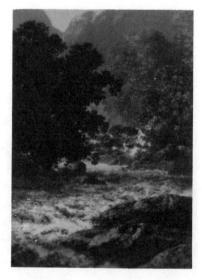

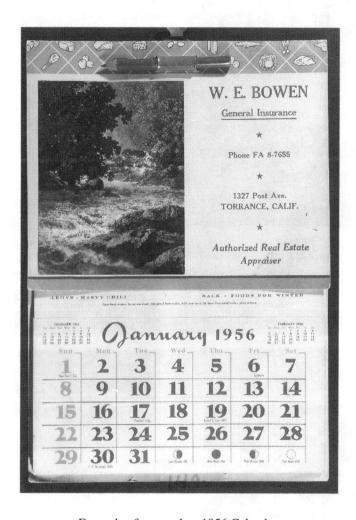

Example of a complete 1956 Calendar

MORNING LIGHT (THE LITTLE STONE HOUSE)

1957	Complete	Cropped
Miniature	\$45-\$50	\$15-\$20
X-Small	\$65-\$75	\$20-\$25
Small	\$240-\$285	\$170-\$200
Medium	\$330-\$370	\$230-\$260
Large	\$460-\$520	\$310-\$350

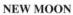

1958	Complete	Cropped
Miniature	\$50-\$55	\$15-\$20
X-Small	\$80-\$85	\$25-\$30
Small	\$260-\$310	\$180-\$210
Medium	\$340-\$400	\$240-\$280
Large	\$495-\$560	\$330-\$380

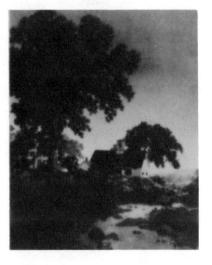

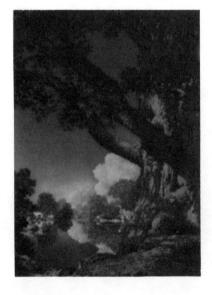

UNDER SUMMER SKIES (IANION'S MAPLE)

(JAMON S MAILE)		
1959	Complete	Cropped
Miniature	\$50-\$55	\$15-\$20
X-Small	\$65-\$75	\$20-\$25
Small	\$250-\$285	\$180-\$200
Medium	\$320-\$370	\$230-\$260
Large	\$460-\$540	\$320-\$360

SHELTERING OAKS (A NICE PLACE TO BE)

1960	Complete	Cropped
Miniature	\$45-\$50	\$15-\$20
X-Small	\$70-\$80	\$25-\$30
Small	\$210-\$260	\$150-\$180
Medium	\$280-\$330	\$200-\$235
Large	\$420-\$495	\$280-\$320

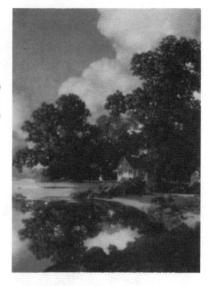

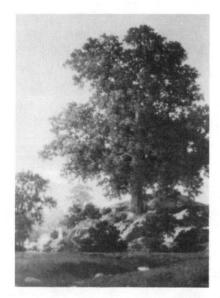

TWILIGHT (THE WHITE OAK)

1961	Complete	Cropped
Miniature	\$40-\$45	\$15-\$20
X-Small	\$55-\$70	\$20-\$25
Small	\$210-\$250	\$150-\$170
Medium	\$270-\$320	\$190-\$220
Large	\$400-\$450	\$275-\$300

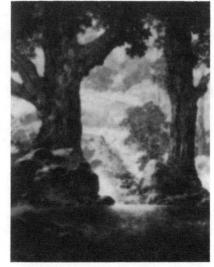

QUIET SOLITUDE (CASCADES)

Complete	Cropped
\$50-\$55	\$15-\$20
\$65-\$80	\$20-\$25
\$260-\$300	\$185-\$210
\$350-\$400	\$250-\$280
\$515-\$585	\$345-\$385
	\$50-\$55 \$65-\$80 \$260-\$300 \$350-\$400

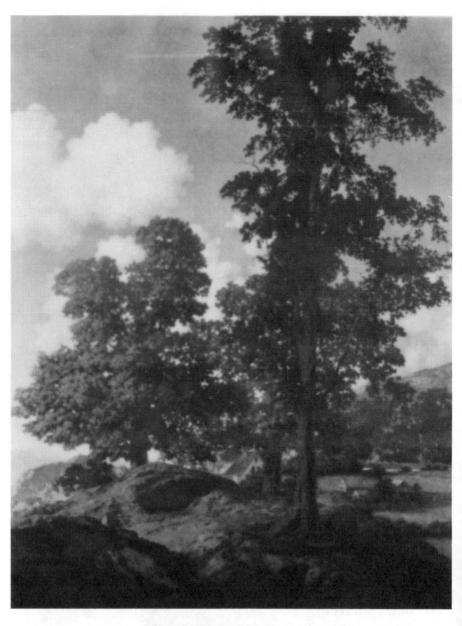

PEACEFUL COUNTRY

		-
1963	Complete	Cropped
Miniature	\$45-\$50	\$15-\$20
X-Small	\$65-\$75	\$20-\$25
Small	\$240-\$280	\$170-\$200
Medium	\$310-\$370	\$220-\$260
Large	\$485-\$545	\$325-\$365

BROWN & BIGELOW WINTER CALENDARS

"An artist is best, needless to say, in the things he likes best. I am most happy in out-of-door things, subjects in nature's own light: fanciful things, in color and design, belonging to no particular time or place."

Maxfield Parrish January 22, 1934 Brown and Bigelow winter calendars are mostly referred to by the title given by the publisher. However, there are occasions when the artist's title may be used. Both titles have been listed when known (Parrish titles in parentheses).

The winter calendars were printed in odd sizes from year to year ranging from 8 1/2" X 11" to 12 1/2" X 17". Refer to the "Reproductions" chapter for more information about newer reproductions and their measurements.

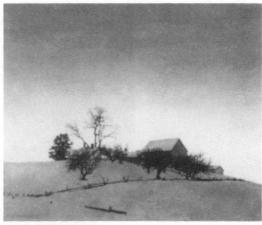

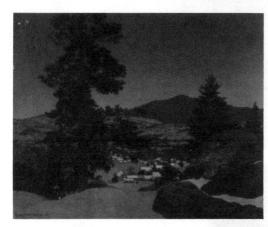

SILENT NIGHT (WINTER NIGHT) 1942 \$180-\$240

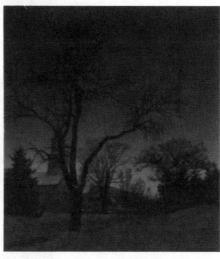

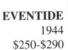

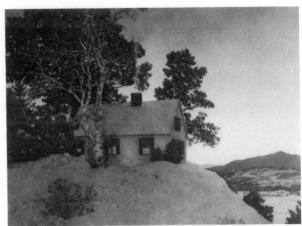

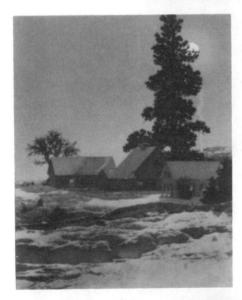

LIGHTS OF HOME or SILENT NIGHT 1945 \$170-\$230

THE PATH TO HOME (ACROSS THE VALLEY) 1946 \$180-\$230

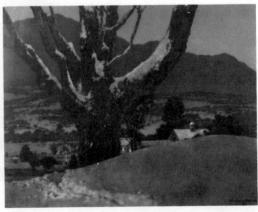

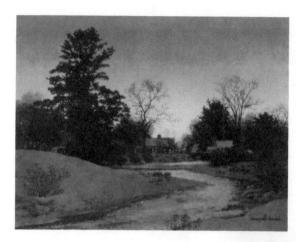

PEACE AT TWILIGHT (LULL BROOK) 1947 \$175-\$240

CHRISTMAS EVE (DEEP VALLEY) 1948 \$190-\$260

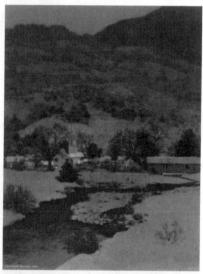

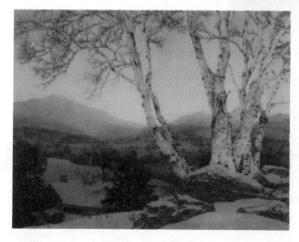

CHRISTMAS MORNING 1949 \$220-\$270

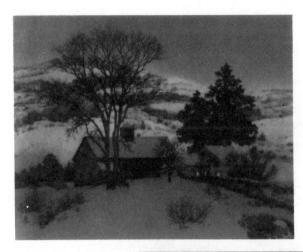

A NEW DAY (**AFTERGLOW**) 1950 \$210-\$270

THE TWILIGHT HOUR 1951 \$180-\$240

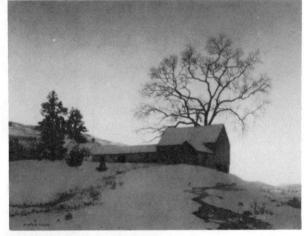

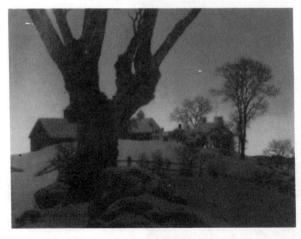

LIGHTS OF WELCOME 1952 \$190-\$240

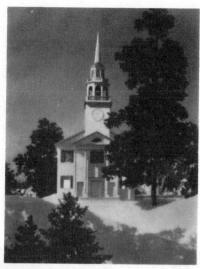

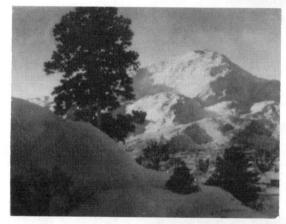

WHEN DAY IS DAWNING (WINTER SUNRISE) 1954 \$200-\$250

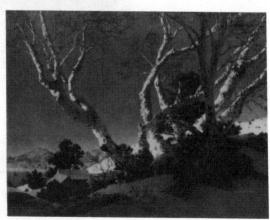

SUNRISE (WHITE BIRCHES IN A GLOW) 1955 \$200-\$275

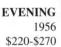

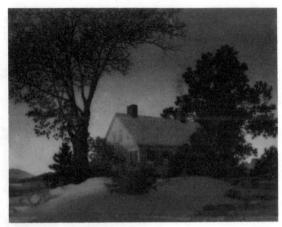

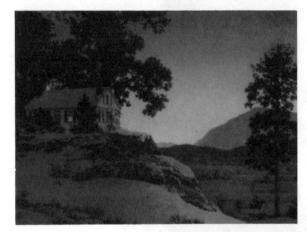

AT CLOSE OF DAY (NORWICH, VERMONT) 1957 \$200-\$270

SUNLIGHT (WINTER SUNSHINE) 1958 \$220-\$280

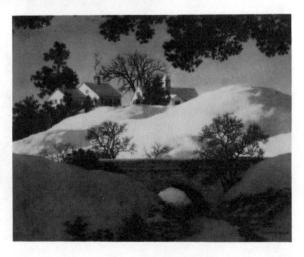

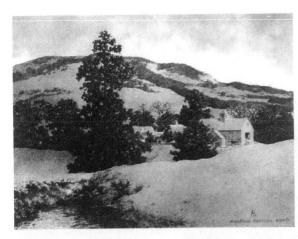

PEACE OF EVENING (DINGLETON FARM) 1959 \$190-\$240

TWILIGHT TIME (FREEMAN FARM) 1960 \$190-\$230

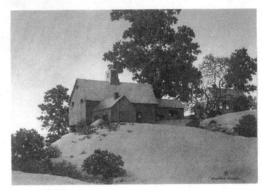

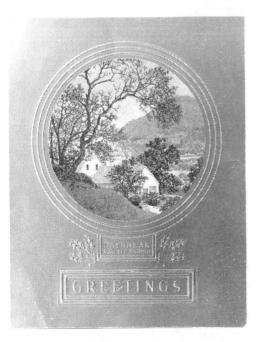

DAYBREAK 1961 \$210-\$260

EVENING SHADOWS 1962 \$220-\$275

ILLUSTRATED BOOKS

"I'd rather paint two pictures than try to tell WHY I painted one."

Maxfield Parrish June 4, 1936

Child the steer company to be set on the first of the fir

AMERICAN ART BY AMERICAN ARTISTS

1898-1914 / \$85-\$125 Each
"One Hundred Favorite Paintings"
A series of editions containing color plates from "The
Arabian Nights" and "A Wonderbook and Tanglewood Tales"
Plate sizes average 12" X 16"
P.F. Collier & Son

AMERICAN COLLECTOR 1974, March / \$10-\$15

AMERICAN HERITAGE

1970, December / \$25-\$35

AMERICAN PICTURES AND THEIR PAINTERS

1917 / \$50-\$70

Author: Lorinda M. Bryant Three illustrations in black and white from the Florentine Fete Murals John Lane Company

THE ANNUAL OF ADVERTISING ART IN THE UNITED STATES

1921 Containing five illustrations in black and white / \$60-\$80 1923 Containing two illustrations in black and white / \$50-\$60 1924 Containing three illustrations in black and white / \$50-\$70 1925 Containing three illustrations in black and white / \$50-\$70

THE ARABIAN NIGHTS, THEIR BEST KNOWN TALES

1909

Editors: Kate Wiggin & Nora Smith Containing twelve illustrations in color Charles Scribner's Sons

\$175-\$220

Later versions contain nine illustrations in color \$120-\$150

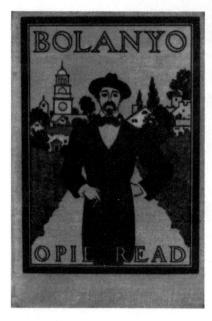

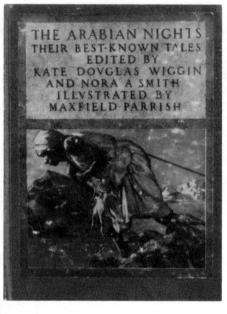

BOLANYO 1897 / \$160-\$200 Author: Opie Read Cover in two color Back cover is same as front Way & Williams

THE CHILDREN'S BOOK

1907 / \$80-\$100

Editor: Horace E. Scudder

Cover in color

Houghton Mifflin Company

(See "Magazines")

DREAM DAYS

1898 / \$150-\$190

Author: Kenneth Grahame Ten illustrations in black and white Three tailpieces in black and white John Lane Company Second edition 1902 / \$90-\$110

THE EMERALD STORY BOOK

1917 / \$100-\$140

Author: Ada and Eleanor Skinner

Frontispiece in color Duffield & Company (See "Magazines")

FREE TO SERVE 1897 / \$110-\$150 Author: Emma Rayner Cover in color Copeland & Day

THE GARDEN OF YEARS AND OTHER POEMS

1904 / \$70-\$90

Author: Guy Wetmore Carryl

Frontispiece in color G.P. Putnam's Sons

THE GOLDEN AGE

1899 / \$150-\$190

Author: Kenneth Grahame Nineteen illustrations in black and white Thirteen tailpieces in black and white John Lane Company

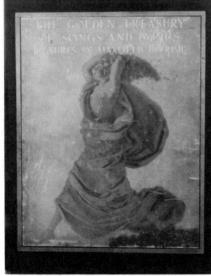

THE GOLDEN TREASURY OF SONGS AND LYRICS

1911 / \$190-\$240

Author: Francis Turner Palgrave Eight illustrations in color **Duffield & Company**

Second edition 1941 / \$60-\$90

(Contains only four illustrations in color)

GRAPHIC ARTS AND CRAFTS YEARBOOK

1907 / \$40-\$60

Editor: Joseph Meadon Two illustrations in color Republican Publishing Company

THE HISTORY AND IDEALS OF **AMERICAN ART**

1931 / \$25-\$40

Author: Eugene Neuhaus

Two illustrations in black and white

Stanford University Press

ITALIAN VILLAS AND THEIR GARDENS

1904 / \$225-\$300

Author: Edith Wharton Fifteen illustrations in color Eleven illustrations in black and white The Century Company

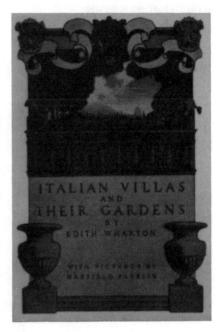

THE JUNIOR CLASSICS

1912 Vol. II / \$35-\$50

Editor: William Patten Frontispiece in color P.F. Collier & Son

THE JUNIOR CLASSICS

1912 Vol. III / \$50-\$60

Editor: William Patten One color frontispiece

Three illustrations in black and white

P.F. Collier & Son

KING ALBERT'S BOOK

1914 / \$100-\$125

Editor: The Daily Telegraph Illustration in color "Dies Irae"

Hearst's International Library Company

THE KNAVE OF HEARTS

1925

Author: Louise Saunders Twenty-three illustrations in color Charles Scribner's Sons Hardbound in box / \$1600-\$1800 Hardbound / \$1200-\$1500 Spiral / \$650-\$800 (Spiral did not have cover lining "Romance")

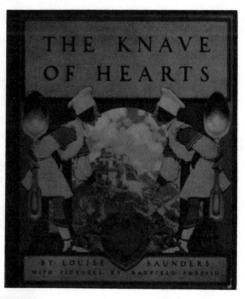

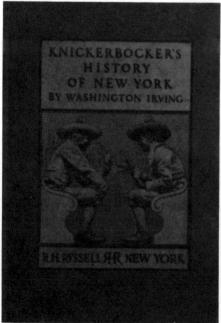

KNICKERBOCKER'S HISTORY OF NEW YORK

1900 / \$275-\$350

Author: Washington Irving

Eight illustrations in black and white

R.H. Russell

Second edition / \$125-\$160

LURE OF THE GARDEN

1911 / \$50-\$70

Author: Hildegarde Hawthorne

Illustration in color The Century Company

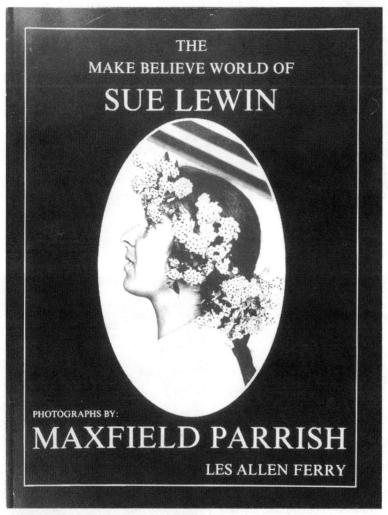

MAKE BELIEVE WORLD OF SUE LEWIN

1978 / \$65-\$75 Author: L.A. Ferry

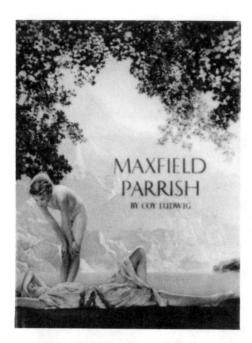

MAXFIELD PARRISH

1973 / \$70-\$80 Author: Coy Ludwig Sixty-four illustrations in color One hundred two illustrations in black and white Watson-Guptill Publications Second edition 1974 / \$50-\$60

MAXFIELD PARRISH THE EARLY YEARS

1973 / \$250-\$300

Author: Paul W. Skeeters
One hundred seventy illustrations in color
Sixty illustrations in black and white
Nash Publishing
Also published by Chartwell Books
with a lesser color and image quality
Second edition 1974 / \$230-\$270

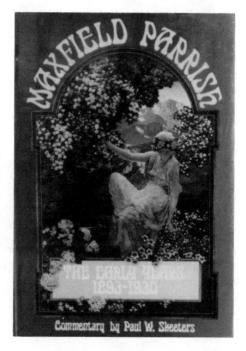

MAXFIELD PARRISH THE EARLY YEARS (JAPANESE VERSION) 1974 / \$75-\$100

MAXFIELD PARRISH "IN THE BEGINNING" 1976 / \$75-\$95 Author: Virginia Hunt Reed

Imperial Printers

MAXFIELD PARRISH POSTER BOOK

1974 / \$25-\$35

Introduction: Maurice Sendak Twenty-three illustrations in color Bruce Harris, Publisher

Bruce Harris, Publisher Numerous reprints exist

MAXFIELD PARRISH PRINTS

1974 / \$15-\$20

Author: Marian S. Sweeney Twenty-one illustrations in black and white

William L. Bauhan, Publisher

MODERN ILLUSTRATING

1930 / \$30-\$40

Editors: Charles Bartholomew & Joseph Almars

Two illustrations in black and white

Federal Schools Publishing

MOTHER GOOSE IN PROSE

1897 / \$1200-\$1500

Author: L. Frank Baum

Thirteen illustrations in black and white Twenty-two headpieces in black and white

Way and Williams Numerous reprints exist

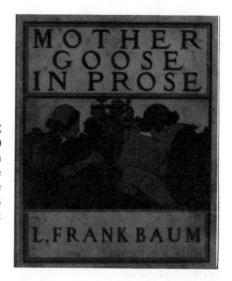

MURAL PAINTING IN AMERICA

1913 / \$30-\$50

Author: Edwin H. Blashfield

Two illustrations in black and white

Charles Scribner's Sons

PETERKIN

1912 / \$75-\$100

Author: Gabrielle E. Jackson

Cover and frontispiece (the same) in color

Duffield & Company (See "Magazines")

POEMS OF CHILDHOOD

1904 / \$160-\$200 Author: Eugene Field Nine illustrations in color Charles Scribner's Sons

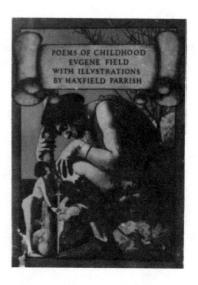

POSTERS: A CRITICAL STUDY OF THE DEVELOPMENT OF POSTER DESIGN

1913 / \$90-\$125

Author: Charles Matlack Price Two illustrations in color Three illustrations in black and white George W. Bricka, Publisher

POSTERS IN MINIATURE

1897 / \$100-\$130 Two illustrations in black and white R.H. Russell

ROMANTIC AMERICA

1913 / \$50-\$60

Author: Robert Haven Schauffler Frontispiece in color The Century Company

THE RUBY STORY BOOK

1921 / \$90-\$130 Frontispiece in color Duffield & Company

THE SAPPHIRE STORY BOOK

1919 / \$100-\$130 Frontispiece in color Duffield & Company

SONG OF HIAWATHA

1912 / \$100-\$120 Author: Henry Wadsworth Longfellow Cover in color Houghton Mifflin Company

THIRTY FAVORITE PAINTINGS

1908 / \$150-\$200

Illustration in color "Pierrot's Serenade" P.F. Collier & Son

THE TOPAZ STORY BOOK

1917 / \$100-\$125

Author: Ada and Eleanor Skinner Frontispiece in color Duffield & Company

TROUBADOUR TALES

1903 / \$60-\$80 Author: Evaleen Stein Frontispiece in color Bobbs-Merrill Company Second edition 1929 / \$25-\$40

THE TURQUOISE CUP AND THE DESERT

1903 / \$60-\$75

Author: Arthur Cosslett Smith Frontispiece in color Two headpieces in black and white Charles Scribner's Sons Second edition 1910 / \$30-\$50

THE TURQUOISE STORY BOOK

1916 / \$100-\$130

Author: Ada and Eleanor Skinner Frontispiece in color

Duffield & Company

WATER COLOUR RENDERING SUGGESTIONS

1917 / \$200- \$250 Seven illustrations in black and white J.H. Jansen, Printing Co.

WHIST REFERENCE BOOK

1897 / \$150-\$190 Author: Butler Title page in color John C. Yorston and Company "Ye Royall Recepcioun"

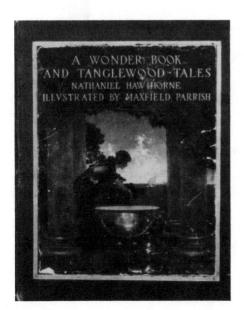

A WONDERBOOK AND TANGLEWOOD TALES

1910 / \$200-\$240

Author: Nathaniel Hawthorne Ten illustrations in color Duffield & Company The following are newly released books on or which include the works of Maxfield Parrish:

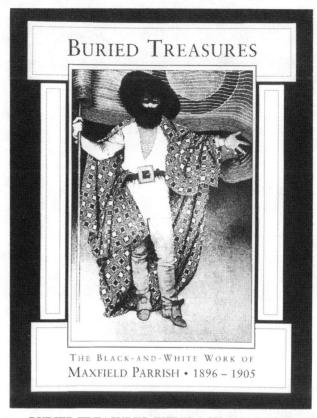

BURIED TREASURES, THE BLACK AND WHITE WORK OF MAXFIELD PARRISH

Author: Fershid Bharucha and Rosalie Grimes

Pomegranate Artbooks 1992

THE COLLECTIBLE MAXFIELD PARRISH

Author: William Holland and Douglas Congdon-Martin

Schiffer Publishing, Ltd. 1993

THE GREAT AMERICAN ILLUSTRATORS

Authors: Judy Goffman and The American Illustrator's Gallery of New York 1993

THE KNAVE OF HEARTS

Ten Speed Press 1993

MAXFIELD PARRISH

Authors: Laurence S. Cutler and Judy Goffn Bison Books 1993

YOUNG MAXFIELD PARRISH

Author: John Goodspeed Stuart T.H. Pickens Technical Center 1992

ILLUSTRATED MAGAZINES

"I would rather have a tooth pulled than sit for a picture."

Maxfield Parrish February 12, 1898 Magazines generally fall into two main groups: newstand issues, which were sold flat; and subscription issues which were often times mailed with an address label affixed to the front cover.

The subscription issues usually suffered from a verticle crease through the center of the image.

Where a price is listed for a magazine cover in this chapter, it means just that - for the cover only.

Add a price increase of 35% for complete newstand issues and a price increase of 25% for complete subscription issues.

AGRICULTURAL LEADER'S DIGEST

1934, November / \$45-\$50 Cover in color

AMERICAN ARTIST 1973, October / \$20-\$30

AMERICAN MAGAZINE

1918, SEPTEMBER / \$65-\$80 Back cover advertisement in color for Djer-Kiss Cosmetics

AMERICAN MAGAZINE

1921, May / \$30-\$35 Illustration in color "Be My Valentine"

AMERICAN MAGAZINE

1921, July / \$25-\$30 Advertisement in sepia for Hires Root Beer

THE AMERICAN MAGAZINE OF ART

1918, January / \$40-\$45
"The Art of Maxfield Parrish"
Containing sixteen black and white illustrations of Parrish-illustrated books, magazine covers, a Florentine Fete mural and a Fisk
Tire advertisement

AMERICAN MONTHLY REVIEW OF REVIEWS

1900, December / \$15-\$20 Illustration in black and white "Father Knickerbocker"

AMERICAN MONTHLY REVIEW OF REVIEWS

1918, February / \$75-\$95 Advertisement in color "And Night is Fled" (See "E.M. Calendars")

ANTIQUES
1936, October / \$5-\$10
Illustration in black and white "Daybreak"

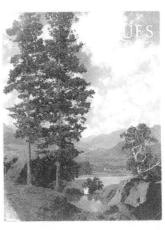

ANTIQUE TRADER 1978, May 31 / \$10-\$15 Cover in color "Daybreak"

ARCHITECTURAL LEAGUE OF NEW YORK YEARBOOK

1914 / \$15-\$20

Two illustrations in black and white from the Florentine Fete murals

ARCHITECTURAL LEAGUE OF NEW YORK YEARBOOK

1917 / \$25-\$30

Two illustrations in black and white of a mural for the studio of Mrs. Payne Whitney One illustration in black and white from the Florentine Fete murals

ARCHITECTURAL RECORD

1907, January / \$15-\$20 Illustration in black and white "Old King Cole" (St. Regis)

ART INTERCHANGE

1896, June / \$40-\$50

Two illustrations in black and white of two prize-winning entries in poster contest, one for Pope Manufacturing, one for Century Magazine

ART JOURNAL

1903, June / \$10-\$15 Illustration in black and white "The Reluctant Dragon"

THE ARTIST

1898 / \$45-\$55

Two illustrations in black and white of posters, one from Century Magazine, August 1897, and one from Scribner's, August 1897

Author: Butler
Title page in color
John C. Yorston and Company
"Ye Royall Recepcioun"

ARTS AND DECORATION

1923, October / \$5-\$10 Illustration in black and white "Daybreak"

ATLANTIC MONTHLY

1921, June / \$35-\$45

Advertisement in color for Hires Root Beer

ATLANTIC MONTHLY

1922, February / \$35-\$45 Advertisement in color for Jello "The King and Queen Might Eat Thereof"

ATLANTIC MONTHLY

1925, December / \$15-\$20
Illustration in black and white "Potato Peelers"

BOOK BUYER

1897, Christmas / \$130-\$150 Cover in color

BOOK BUYER

1898, April / \$35-\$40

Five illustrations in black and white

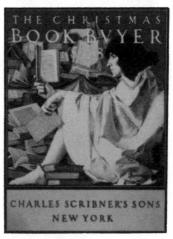

BOOK BUYER

1898, December / \$120-\$140 Cover in color

BOOK BUYER

1899, April / \$110-\$120 Cover in color

BOOK BUYER

1899, December / \$110-\$130 Cover in black and white

THE BOOKMAN

1899, February / \$20-\$25 Illustration in black and white "The Three Wise Men of Gotham"

THE BOOKMAN

1900, September / \$20-\$25 Illustration in black and white "Saint Nicholas"

BOOK NEWS

1895, February / \$90-\$100 Cover in black and white Also same cover design for October-December 1895 and January-February 1896

BOOK NEWS

1896, March-September / \$80-\$90 Covers in color all sharing the same design of a woman bending over reading a book

BOOK NEWS

1897, March-April / \$70-\$85 Cover designs same as previous, but with different colors

BOOK NEWS

1897, June / \$90-\$120 Cover in black and white with light blue sky A woman reading a book with castles in the background

BRADLEY, HIS BOOK

1896, November / \$60-\$100 Four illustrations in black and white which include a poster for the Philadelphia Horse Show Association, a program cover for the Mask and Wig Club, a frontispiece and tailpiece

BRUSH AND PENCIL

1898, January / \$45-\$55 Three illustrations in black and white "The Man in the Moon," "Jack Horner" and "The Wond'rous Wise Man"

CANADIAN HOME AND GARDEN 1927, May / \$20-\$25 Advertisement in black and white

CENTURY MAGAZINE

1898, December / \$30-\$35 Double frontispiece in sepia

1899, December / \$15-\$20 Illustration in black and white "A Hill Prayer" Also two page decorations

CENTURY MAGAZINE

1900, July / \$10-\$15 Illustration in black and white

CENTURY MAGAZINE

1900, December / \$40-\$50 Advertisement in black and white for Fisk Tires "The Magic Circle"

CENTURY MAGAZINE

1901, January / \$15-\$30 Illustration in black and white Also three page decorations One page decoration shown here

CENTURY MAGAZINE

1901, January / \$15-\$30 Illustration in black and white Also three page decorations One page decoration shown here

1901, December / \$40-\$45 Four illustrations in black and white Also one black and white bookplate

CENTURY MAGAZINE

1902, May / \$50-\$60 Two illustrations in color Four illustrations in black and white from "The Great Southwest"

CENTURY MAGAZINE

1902, June / \$30-\$35
Five illustrations in black and white from "The Great Southwest"

CENTURY MAGAZINE

1902, July / \$25-\$30 Four illustrations in black and white from "The Great Southwest"

CENTURY MAGAZINE

1902, August / \$25-\$30 Four illustrations in black and white from "The Great Southwest"

CENTURY MAGAZINE

1902, November / \$75-\$110 Seven illustrations in color from "The Great Southwest"

CENTURY MAGAZINE

1903, November / \$35-\$45 Four illustrations in color and one illustration in black and white from "Italian Villas and Their Gardens"

CENTURY MAGAZINE

1903, December / \$25-\$30 Three illustrations in color from "Italian Villas and Their Gardens"

CENTURY MAGAZINE

1904, February / \$25-\$35 Two illustrations in color and three illustrations in black and white from "Italian Villas and Their Gardens," also includes a headpiece

CENTURY MAGAZINE

1904, April / \$25-\$30 Two illustrations in color and two illustrations in black and white from "Italian Villas and Their Gardens"

CENTURY MAGAZINE

1904, August / \$35-\$40 Four illustrations in color from "Italian Villas and Their Gardens"

CENTURY MAGAZINE

1904, October / \$25-\$30 One illustration in color and five illustrations in black and white from "Italian Villas and Their Gardens," also includes the title page

CENTURY MAGAZINE 1904, November / \$15-\$20 Illustration in color "Ode to Autumn"

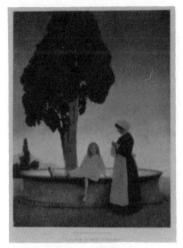

CENTURY MAGAZINE 1904, December / \$20-\$25 Illustration in color "I Am Sick of Being a Princess"

1905, March / \$15-\$20 Illustration in black and white "A Journey Through Sunny Provence"

CENTURY MAGAZINE

1905, October / \$35-\$55 Frontispiece in color "The Sandman"

CENTURY MAGAZINE

1910, August / \$20-\$25 Frontispiece in color

CENTURY MAGAZINE

1910, November / \$10-\$15 Illustration in black and white

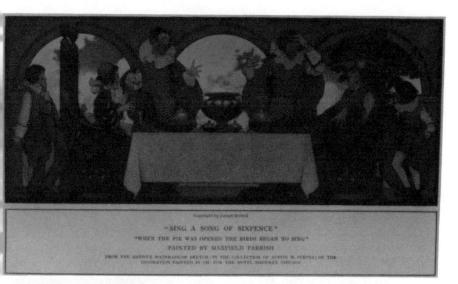

1911, February / \$30-\$50 Illustration in color "Sing a Song of Sixpence"

CENTURY MAGAZINE

1911, April / \$35-\$50 Illustration in color "Quod Erat Demonstrandum" (Proving It by the Book)

CENTURY MAGAZINE

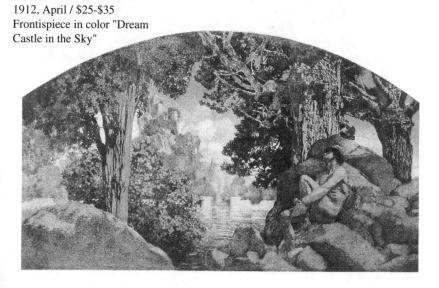

1912, July / \$50-\$70 Five illustrations in black and white and ten paper cut outs and illustrations

CENTURY MAGAZINE

1912, August / \$45-\$60 Six illustrations in black and white from the Florentine Fete murals

CENTURY MAGAZINE 1915, December / \$35-\$45 Frontispiece in color "Pipe Night at the Players"

CENTURY MAGAZINE

1917, August / \$75-\$90 Cover in color

CENTURY MAGAZINE

1918, December / \$30-\$35 Advertisement in color for Community Plate

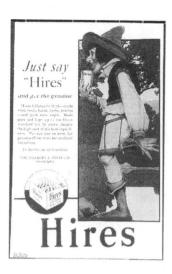

1921, June / \$25-\$30 Advertisement in color for Hires Root Beer

CENTURY MAGAZINE

1921, July / \$25-\$30 Advertisement in color for Hires Root Beer

CHRISTIAN HERALD

1919, March / \$70-\$80 Advertisement in color for Ferry Seeds "Peter, Peter" (See "Posters")

COLLIER'S MAGAZINE

1904, April 30 / \$5-\$10 Headpiece in black and white

COLLIER'S MAGAZINE

1904, June 25 / \$5-\$10 Headpiece in black and white

COLLIER'S MAGAZINE

1904, October 29 / \$5-\$10 Headpiece in black and white

COLLIER'S MAGAZINE

1904, December 3 / \$80-\$100 Cover in color "Three Shepherds" (See "Prints")

COLLIER'S MAGAZINE 1905, January 7 / \$80-\$100 Cover in color "Father Time"

COLLIER'S MAGAZINE

1905, January 21 / \$5-\$10 Headpiece in black and white

COLLIER'S MAGAZINE

1905, February 11 / \$35-\$45 Cover in color Also a headpiece in black and white

COLLIER'S MAGAZINE

1905, March 4 / \$25-\$40 Cover in color, frame around a photograph of President Roosevelt

COLLIER'S MAGAZINE

1905, April 8 / \$5-\$10 Headpiece in black and white

COLLIER'S MAGAZINE

1905, April 15 / \$80-\$90 Cover in color "Easter" (See "Prints")

COLLIER'S MAGAZINE

1905, May 6 / \$75-\$90 Cover in color "Spring" (See "Prints")

COLLIER'S MAGAZINE

1905, May 20 and June 3 / \$35-\$45 Permanent cover design in color

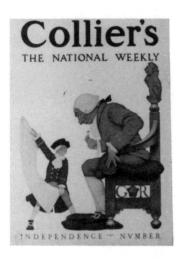

COLLIER'S MAGAZINE 1905, July 1 / \$80-\$100 Cover in color

COLLIER'S MAGAZINE

1905, July 22 / \$70-\$80 Cover in color "Summer" (See "Prints")

COLLIER'S MAGAZINE

1905, August 5 / \$30-\$40 Permanent cover design in color

COLLIER'S MAGAZINE

1905, September 23 / \$60-\$80 Cover in color "Harvest" (See "Prints")

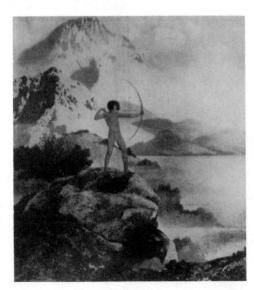

COLLIER'S MAGAZINE 1905, October 14 / \$120-\$160 Cover in color "Hiawatha"

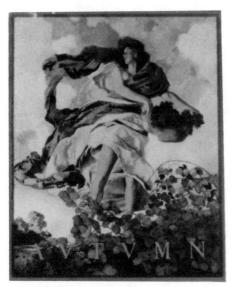

COLLIER'S MAGAZINE 1905, October 28 / \$90-\$130 Cover in color "Autumn"

COLLIER'S MAGAZINE 1905, November 4 / \$30-\$40 Permanent cover design in color

COLLIER'S MAGAZINE 1905, December 2 / \$30-\$40 Permanent cover design in color

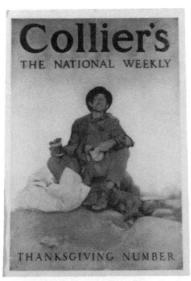

COLLIER'S MAGAZINE 1905, November 18 / \$75-\$85 Cover in color "Tramp's Thanksgiving"

COLLIER'S MAGAZINE 1905, December 16 / \$80-\$90 Cover in color "The Boar's Head"

COLLIER'S MAGAZINE 1906, January 6 / \$70-\$85 Cover in color

COLLIER'S MAGAZINE 1906, February 3 / \$35-\$40 Permanent cover design in color

COLLIER'S MAGAZINE 1906, February 10 / \$65-\$85 Cover in color

COLLIER'S MAGAZINE 1906, March 10 / \$60-\$75 Cover in color "Winter"

1906, April 7 / \$25-\$35 Frontispiece in color "The Fisherman and the Genie" (See "Prints")

COLLIER'S MAGAZINE 1906, April 14 / \$35-\$40

Permanent cover design in color

COLLIER'S MAGAZINE

1906, April 21 / \$5-\$10 Headpiece in black and white

COLLIER'S MAGAZINE 1906, May 19 / \$80-\$90 Cover in color "Milking Time"

COLLIER'S MAGAZINE 1906, June 23 / \$80-\$100 Cover in color "The Gardener"

1906, July 21 / \$80-\$100 Cover in color "The Swing"

COLLIER'S MAGAZINE

1906, September 1 / \$35-\$50 Frontispiece in color Also four headpieces in black and white

COLLIER'S MAGAZINE

1906, October 13 / \$25-\$35 Frontispiece in color "Prince Agib" (See "Prints")

COLLIER'S MAGAZINE

1906, October 27 / \$5-\$10 Headpiece and tailpiece in black and white

COLLIER'S MAGAZINE

1906, November 3 / \$25-\$35 Frontispiece in color "Cassim in the Cave" (See "Prints")

COLLIER'S MAGAZINE 1906, July 7 / \$90-\$110 Cover in color

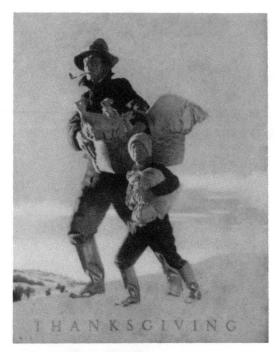

COLLIER'S MAGAZINE 1906, November 17 / \$80-\$100 Cover in color

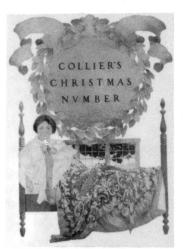

1906, December 1 / \$25-\$40 Frontispiece in color "Search for the Singing Tree" (See "Prints")

COLLIER'S MAGAZINE

1906, December 15 / \$30-\$40 Frontispiece in color Also a black and white page decoration

COLLIER'S MAGAZINE

1906, December 22 / \$20-\$30 1907 Calendar advertisement in black and white showing two illustrations, "Summer" and Collier's cover from January 7, 1905

COLLIER'S MAGAZINE 1907, January 5 / \$80-\$90 Cover in color

COLLIER'S MAGAZINE
1907, February 9 / \$25-\$40
Frontispiece in color "Sinbad Plots
Against the Giant"
(See "Prints")

1907, January 19 / \$35-\$45 Permanent cover design in color

COLLIER'S MAGAZINE

1907, March 16 / \$25-\$35 Frontispiece in color "The City of Brass" (See "Prints")

COLLIER'S MAGAZINE

1907, March 30 / \$15-\$20 Two page decorations

COLLIER'S MAGAZINE

1907, May 18 / \$25-\$35 Frontispiece in color "King of the Black Isles" (See "Prints")

COLLIER'S MAGAZINE

1907, June 22 / \$25-\$35 Frontispiece in color "Aladdin and the Wonderful Lamp" (See "Prints")

COLLIER'S MAGAZINE

1907, August 3 / \$25-\$40 Frontispiece in color "Queen Gulnare" (See "Prints")

COLLIER'S MAGAZINE

1907, September 7 / \$25-\$35 Frontispiece in color "The Valley of Diamonds" (See "Prints")

1907, November 9 / \$25-\$35 Frontispiece in color "Landing of the Brazen Boatman" (See "Prints")

COLLIER'S MAGAZINE

1907, November 30 / \$65-\$80 Cover in color "Oklahoma Comes In"

COLLIER'S MAGAZINE

1907, December 28 / \$5-\$10 Advertisement in black and white "The Fisherman and the Genie" (See "Prints")

COLLIER'S MAGAZINE

1908, January 11 / \$5-\$10 Headpiece in black and white Also a page decoration

COLLIER'S MAGAZINE

1908, January 25 / \$25-\$35 Frontispiece in color "Circe's Palace" (See "Prints")

COLLIER'S MAGAZINE

1908, May 16 / \$25-\$40 Frontispiece in color "Atlas" (See "Prints")

COLLIER'S MAGAZINE

1908. June 6 / \$80-\$90 Cover in color "Vaudeville"

COLLIER'S MAGAZINE

1908, July 4 / \$80-\$110 Cover in color "A Funnygraph" Also a black and white page heading

COLLIER'S MAGAZINE

1908, July 18 / \$70-\$85 Cover in color "The Botanist"

COLLIER'S MAGAZINE

1908, August 8 / \$70-\$80 Cover in color "Pierrot's Serenade" (See "Prints")

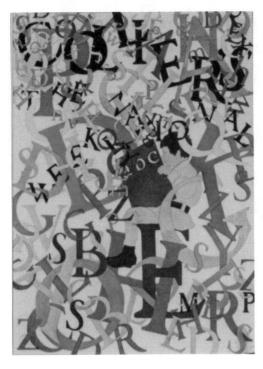

COLLIER'S MAGAZINE 1908, September 12 / \$75-\$90 Cover in color "School Days"

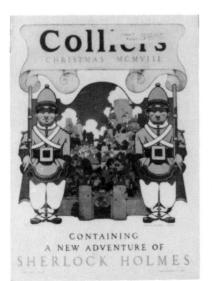

COLLIER'S MAGAZINE

1908, October 31 / \$65-\$85 Frontispiece in color "Cadmus Sowing the Dragon's Teeth" (See "Prints")

COLLIER'S MAGAZINE

1908, December 12 / \$90-\$110 Cover in color "Toyland" Also an illustration entitled "The Knight"

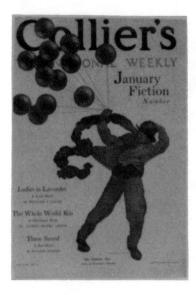

COLLIER'S MAGAZINE 1908, December 26 / \$75-\$85 Cover in color "The Balloon Man"

COLLIER'S MAGAZINE

1909, January 2 / \$80-\$90 Cover in color "The Artist"

COLLIER'S MAGAZINE

1909, March 20 / \$75-\$85 Cover in color "Mask and Pierrot"

COLLIER'S MAGAZINE

1909, March 27 / \$5-\$10 Decoration in black and white for "A Submarine Investigation"

COLLIER'S MAGAZINE

1909, April 3 / \$70-\$80 Cover in color "April Showers"

COLLIER'S MAGAZINE

1909, April 17 / \$75-\$90 Cover in color "The Lone Fisherman" Also a black and white page decoration

COLLIER'S MAGAZINE

1909, April 24 / \$85-\$95 Cover in color "Old King Cole" (Center panel - St. Regis)

COLLIER'S MAGAZINE

1909, May 1 / \$70-\$80 Cover in color "The Artist" (male)

COLLIER'S MAGAZINE

1909, May 15 / \$35-\$45 Frontispiece in color "The Chimera" (Bellerphon by the Fountain of Pirene) (See "Prints")

COLLIER'S MAGAZINE

1909, May 29 / \$70-\$80 Cover in color "Old King Cole" (right panel - St. Regis)

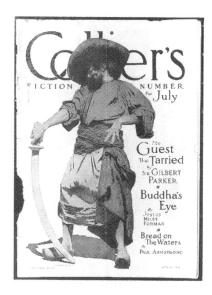

1909, June 26 / \$80-\$90 Cover in color "The Pirate"

COLLIER'S MAGAZINE

1909, July 3 / \$75-\$95
Cover in color "Young America Writing
Declaration of Independence"
Also includes an advertisement in black
and white of "Toyland" poster and
jigsaw puzzles of various prints

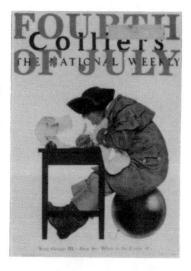

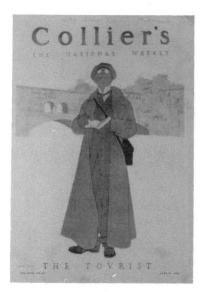

COLLIER'S MAGAZINE

1909, July 10 / \$80-\$90 Cover in color "The Tourist" Also an advertisement for The Arabian Nights prints

1909, July 24 / \$75-\$85 Cover in color "The Signpainter"

COLLIER'S MAGAZINE

1909, October 16 / \$30-\$50 Frontispiece in color "Pandora" (See "Prints")

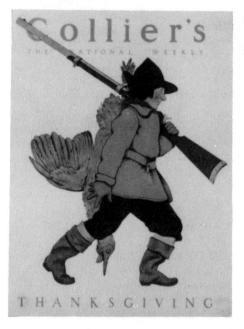

COLLIER'S MAGAZINE

1909, November 20 / \$70-\$80 Cover in color

COLLIER'S MAGAZINE

1909, December 11 / \$85-\$95 Cover in color "The Wassail Bowl" (See "Prints")

COLLIER'S MAGAZINE

1910, January 8 / \$90-\$100 Cover in color of a girl on a sled

COLLIER'S MAGAZINE

1910, March 5 / \$25-\$35 Frontispiece in color "Quest of the Golden Fleece" (See "Prints")

COLLIER'S MAGAZINE

1910, April 23 / \$25-\$40 Frontispiece in color "Proserpina and the Sea Nymphs" (See "Prints")

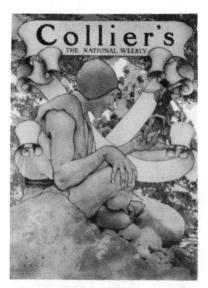

COLLIER'S MAGAZINE 1910, July 30 / \$70-\$90 Cover in color "Courage"

1910, July 23 / \$25-\$35 Frontispiece in color "Jason and his Teacher" (See "Prints")

COLLIER'S MAGAZINE 1910, September 3 / \$75-\$90

Cover in color "Penmanship"

COLLIER'S MAGAZINE

1910, September 24 / \$80-\$90 Cover in color "The Idiot" (Booklover) (See "Prints")

COLLIER'S MAGAZINE

1910, November 26/ \$70-\$90 Cover in color

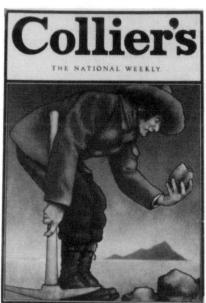

COLLIER'S MAGAZINE
1911, February 4 / \$80-\$90
Cover in color "The Prospector"

COLLIER'S MAGAZINE 1911, March 11 / \$70-\$85 Cover in color "Comic Scottish Soldier"

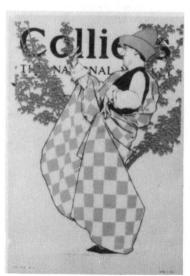

COLLIER'S MAGAZINE

1910, December 10 / \$25-\$40 Frontispiece in color "The Lantern Bearers" (See "Prints")

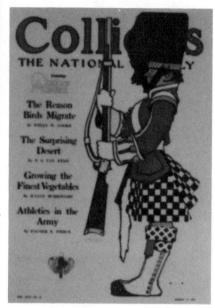

COLLIER'S MAGAZINE

1911, March 18 / \$35-\$45 Permanent cover design in color

COLLIER'S MAGAZINE

1911, April 1 / \$75-\$85 Cover in color "Man with Green Apple"

COLLIER'S MAGAZINE 1911, April 8 / \$30-\$40

Illustration in color "April"

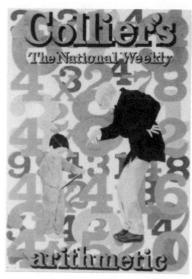

COLLIER'S MAGAZINE 1912, November 2 / \$75-\$90 Cover in color "The Philosopher"

Cover in color of man fishing

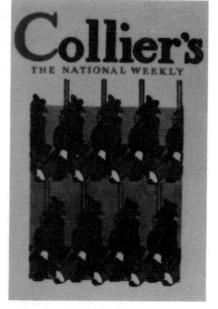

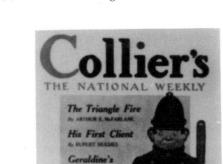

Corn Club"

COLLIER'S MAGAZINE 1913, May 17 / \$65-\$80 Cover in color

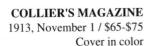

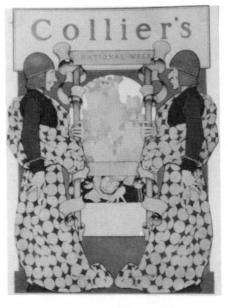

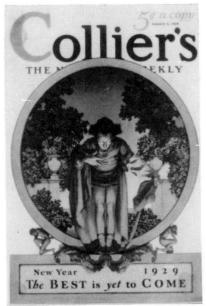

COLLIER'S MAGAZINE 1914, April 6 / \$35-\$45 Permanent cover design

COLLIER'S MAGAZINE 1929, January 5 / \$80-\$100 Cover in color "The End"

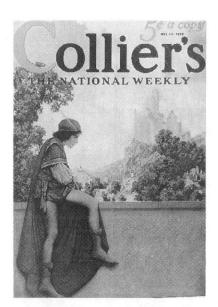

COLLIER'S MAGAZINE 1929, May 11 / \$75-\$95 Cover in color "The Knave Watches Violetta Depart"

COLLIER'S MAGAZINE 1929, July 20 / \$70-\$80 Cover in color

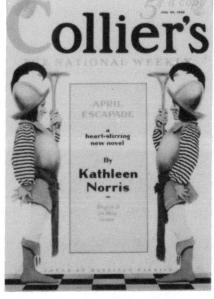

COLLIER'S MAGAZINE 1929, November 30 / \$70-\$90 Cover in color

COLLIER'S MAGAZINE 1936, October 24 / \$75-\$85 Cover in color "Jack Frost" (See "Prints")

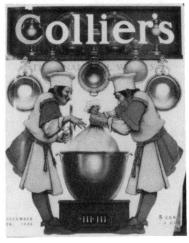

COSMOPOLITAN MAGAZINE

1901, January / \$20-\$30 Eight illustrations and cover design in black and white from Knickerbocker's History of New York

COUNTRY LIFE

1919, August / \$60-\$80 Advertisement in color for Fisk Tires "Mother Goose"

THE CRITIC

1896, April 4 / \$75-\$95 Illustration in black and white of prize-winning poster of a girl on a bicycle (See "Posters")

THE CRITIC

1896, May 16 / \$45-\$75 Illustration in black and white of prize-winning poster for Century Magazine Midsummer Holiday Number (See "Posters")

THE CRITIC

1905, June / \$35-\$65 Article about Parrish containing five illustrations of his work, photographs of his home and shop, and a postage stamp design

DELINEATOR

1921, August / \$75-\$125 Advertisement in color for Djer-Kiss (girl on a swing)

DELINEATOR

1922, March / \$60-\$80 Advertisement in color for Jello "The King and Queen"

EVERYBODY'S MAGAZINE

1901, December / \$25-\$35 Frontispiece in black and white for the story "The Temptation of Ezekiel"

EVERYBODY'S MAGAZINE

1903, May / \$10-\$15 Illustration in black and white for the story "The Growth of the Blood Thirst"

THE FARMER'S WIFE

1922, November / \$60-\$80 Advertisement in color for Jello "The King and Queen"

GOOD HOUSEKEEPING

1925, July / \$20-\$30 Advertisement in sepia for Maxwell House Coffee "The Broadmoor Hotel"

HARPER'S BAZAR

1895, Easter / \$150-\$250 Cover

HARPER'S BAZAR

1896, Easter / \$40-\$50 Advertisement in black and white for Gold Dust Cleansing Powder

HARPER'S BAZAR

1914, March / \$90-\$125 Cover in color "Cinderella" Also an illustration in black and white of "Cinderella"

HARPER'S BAZAR

1922, March / \$60-\$80 Advertisement in color for Jello "The King and Oueen"

HARPER'S MONTHLY MAGAZINE

1896, December / \$100-\$130 Cover in color Christmas MDCCCXCVI

HARPER'S MONTHLY MAGAZINE

1898, April / \$10-\$15 Border around photograph used for "Photographing a Wounded African Buffalo"

HARPER'S MONTHLY MAGAZINE

1898, December / \$10-\$15 Headpiece in black and white used several times for the Contents

HARPER'S MONTHLY MAGAZINE

1900, December / \$60-\$80 Permanent cover design in color

HARPER'S MONTHLY MAGAZINE

1900, Christmas / \$80-\$110 Cover in color

HARPER'S MONTHLY MAGAZINE

1918, December / \$60-\$80 Advertisement for Community Plate

HARPER'S ROUND TABLE

1895, July 2 / \$120-\$190 Cover in color "Fourth of July"

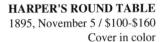

16th Anniversary Number

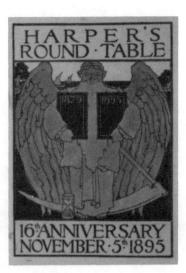

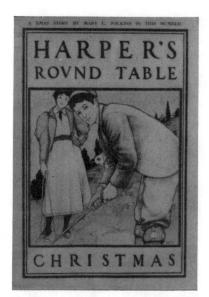

HARPER'S ROUND TABLE 1896, December / \$100-\$140 Cover in color

HARPER'S ROUND TABLE

1897, November / \$60-\$90 Permanent cover design in black and white

HARPER'S ROUND TABLE

1898, December / \$60-\$90 Cover in black and white

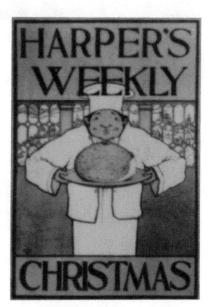

HARPER'S WEEKLY 1895, December 14 / \$125-\$200 Cover in color

HARPER'S WEEKLY

1895, December 14 / \$90-\$110 Back cover advertisement in color for Royal Baking Powder

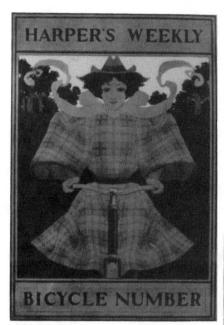

HARPER'S WEEKLY 1896, April 11 / \$90-\$120 Back cover in color Male bicyclist

HARPER'S WEEKLY 1896, April 11 / \$110-\$140 Cover in color Female bicyclist

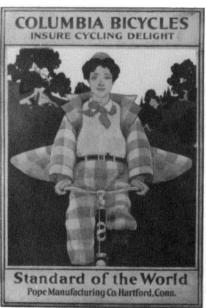

HARPER'S WEEKLY 1896, December 19 / \$100-\$140 Cover in color

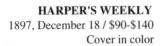

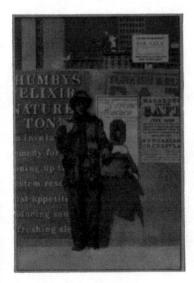

HARPER'S WEEKLY 1900, December 8 / \$40-\$70 Illustration in color "His Christmas Dinner"

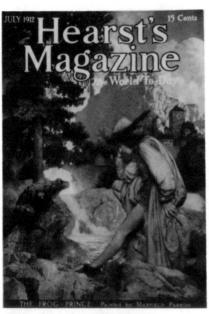

HEARST'S MAGAZINE 1912, July / \$140-\$190 Cover in color "The Frog-Prince"

HEARST'S MAGAZINE

1912, August / \$140-\$190 Cover in color "The Story of Snowdrop"

HEARST'S MAGAZINE 1912, September / \$140-\$190 Cover in color "Hermes"

HARPER'S WEEKLY

1906, April 14 / \$10-\$20 Page decoration for Easter

HARPER'S WEEKLY

1907, December 14 / \$80-\$110 Same cover design as December 18, 1897, but with different colors

HARPER'S WEEKLY

1908, December 12 / \$75-\$100 Same cover design as December 14, 1895, but with different colors

HARPER'S YOUNG PEOPLE

1895, Easter / \$125-\$175 Cover in color

HEARST'S MAGAZINE

1912, June / \$150-\$200 Cover in color "Jack the Giant Killer"

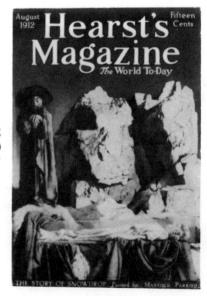

HEARST'S MAGAZINE

1912, November / \$140-\$190 Cover in color "Sleeping Beauty"

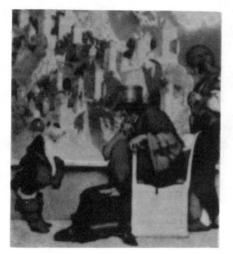

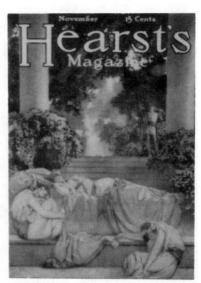

HEARST'S MAGAZINE 1914, May / \$140-\$190 Cover in color "Puss 'n Boots"

HEARST'S MAGAZINE

1922, March / \$60-\$80 Advertisement in color for Jello "The King and Queen"

HOUSE AND GARDEN

1904, April / \$40-\$55 Four illustrations in black and white of decorations in the Mask and Wig Club

HOUSE AND GARDEN

1923, December / \$60-\$90 Advertisement in color for Jello "Polly Put the Kettle On"

HOUSE BEAUTIFUL

1923, June / \$15-\$20 Illustration in black and white "The Spirit of Transportation" (See "Prints")

ILLUSTRATED LONDON NEWS

1910, November 21 / \$60-\$90 Two illustrations in color, both from the book *Dream Days*

ILLUSTRATED LONDON NEWS

1910, December / \$70-\$100 Two illustrations in color "Dies Irae" and "The Reluctant Dragon"

ILLUSTRATED LONDON NEWS

1913, November / \$35-\$55 Illustration in color "Every Plunge of Our Bows Brought Us..."

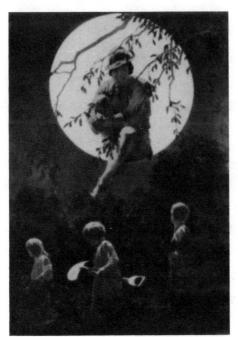

ILLUSTRATED LONDON NEWS 1922, December / \$40-\$60 Illustration in color "A Departure"

INDEPENDENT

1907, November 21 / \$10-\$20 Illustration in black and white from the book *Dream Days*

INTERNATIONAL STUDIO

1898, September / \$25-\$40 Two illustrations in black and white "Old King Cole" and "Wond'rous Wise Man" from the book *Mother Goose in Prose*

INTERNATIONAL STUDIO

1899, December / \$15-\$20 Illustration in black and white "Jason and Argo" from the book *The Golden Age*

ILLUSTRATED LONDON NEWS

1913, December / \$30-\$60 Illustration in color "Its Walls Were as of Jasper"

INTERNATIONAL STUDIO

1906, July / \$30-\$40 Seven illustrations in black and white "A Saga of the Seas," "The Twenty-First of October," "Dies Irae," "The Dinky Bird," "Vi Chigi," "It Was Easy to Transport Yourself," "On to the Garden Wall"

INTERNATIONAL STUDIO

1909, February / \$10-\$20 Photograph in black and white of the poster "Toyland" for art exhibition

INTERNATIONAL STUDIO

1911, January / \$45-\$65 Illustration in color "Old King Cole" (St. Regis)

INTERNATIONAL STUDIO

1912, August / \$10-\$20 Two illustrations in black and white from the Florentine Fete murals

JAMA - THE JOURNAL OF THE AMERICAN MEDICAL ASSOCIATION

1974, October 28 / \$45-\$60 Cover which is an illustration from the chemistry notebook of Maxfield Parrish

LADIES' HOME JOURNAL

1896, July / \$120-\$180 Cover in color of a woman standing by a tree

LADIES' HOME JOURNAL

1901, June / \$70-\$100 Cover in color

LADIES' HOME JOURNAL

1902, December / \$25-\$40 Frontispiece in black and white "The Sugar-Plum Tree" (See "Prints")

LADIES' HOME JOURNAL

1903, February / \$30-\$50 Frontispiece in black and white "Seein' Things at Night"

LADIES' HOME JOURNAL

1903, March / \$25-\$40 Frontispiece in black and white "The Little Peach"

LADIES' HOME JOURNAL

1903, May / \$20-\$35 Frontispiece in black and white "Wynken, Blynken, and Nod" (See "Prints")

LADIES' HOME JOURNAL

1903, July / \$30-\$50 Frontispiece in black and white "With Trumpet and Drum" (See "Prints")

LADIES' HOME JOURNAL

1904, September / \$100-\$125 Cover in color "Air Castles" (See "Prints")

LADIES' HOME JOURNAL

1905. March / \$15-\$20 Illustration in black and white of a circus design used for a child's bedquilt

THE 250TH NUMBER OF THE LADIES' HOME JOURNAL

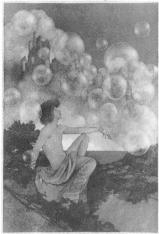

LADIES' HOME JOURNAL

1911. November / \$20-\$40 Announcement of the Florentine Fete murals

LADIES' HOME JOURNAL

1912, May / \$20-\$30 Two illustrations in color "Love's Pilgrimage" and "Lazy Land" from the Florentine Fete murals

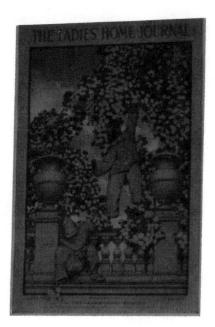

LADIES' HOME JOURNAL

1912, July / \$75-\$95 Cover in color "A Shower of Fragrance" from the Florentine Fete murals

LADIES' HOME JOURNAL

1912, December / \$70-\$90 Cover in color "A Call to Joy" from the Florentine Fete murals

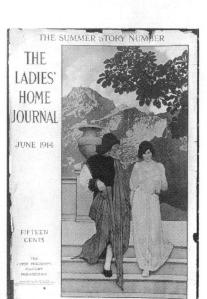

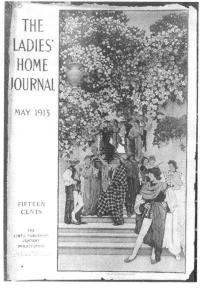

LADIES' HOME JOURNAL

1914, June / \$75-\$95 Cover in color "Garden of Opportunity" from the Florentine Fete murals (See "Prints")

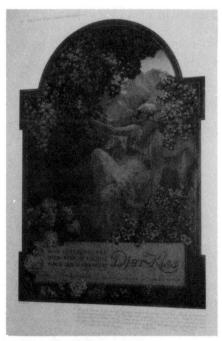

LADIES' HOME JOURNAL 1915, December / \$50-\$70 Illustration in color "The Dream Garden" (See "Prints")

LADIES' HOME JOURNAL 1916, December / \$70-\$100 Advertisement in color for Djer-Kiss Cosmetics

LADIES' HOME JOURNAL 1918, January / \$80-\$110

Advertisement in color "And Night is Fled" (See "E.M. Calendars")

LADIES' HOME JOURNAL 1918, April / \$70-\$100 Advertisement in color for Djer-Kiss Cosmetics

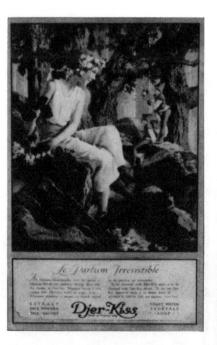

LADIES' HOME JOURNAL 1918, December / \$60-\$80

Advertisement in color for Community Plate

1919, January / \$80-\$120 Advertisement in color "Spirit of the Night" (See "E.M. Calendars")

LADIES' HOME JOURNAL

1920, December / \$50-\$70 Illustration in color "A Florentine Fete"

LADIES' HOME JOURNAL

1921, April / \$150-\$190 Cover in color "Sweet Nothings" from the Florentine Fete murals Also an advertisement in color for Djer-Kiss Cosmetics (See L.H.J. December 1916)

LADIES' HOME JOURNAL

1921, November / \$90-\$110 Advertisement in color for Swift Ham "Jack Sprat" (See "Posters")

LADIES' HOME JOURNAL

1925, July / \$45-\$65 Advertisement in color for Maxwell House Coffee "The Broadmoor Hotel"

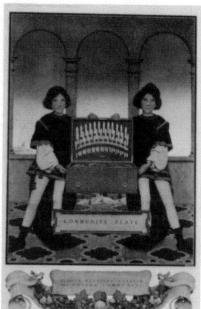

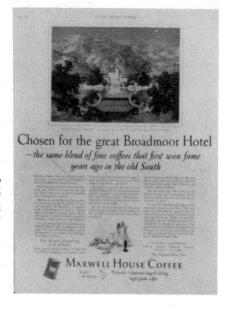

LADIES' HOME JOURNAL 1930, March / \$30-\$40 Frontispiece in color "White Birch" (See "Prints")

LADIES' HOME JOURNAL 1930, June / \$70-\$90 Cover in color

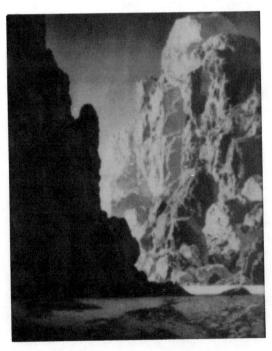

LADIES' HOME JOURNAL 1930, October / \$40-\$50 Frontispiece in color "Arizona"

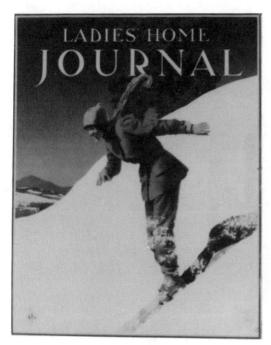

LADIES' HOME JOURNAL 1931, January / \$80-\$90 Cover in color

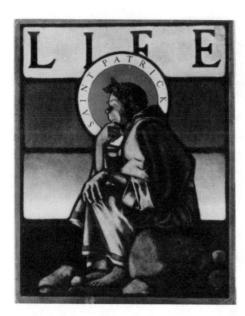

LIFE 1900, December 1 / \$100-\$130 Cover in color, Christmas Number Father Time with clock, book, hourglass, and two servants

LIFE 1904, March 3 / \$90-\$110 Cover in color "St. Patrick"

LIFE 1905, February 2 / \$90-\$120 Cover in color "St. Valentine"

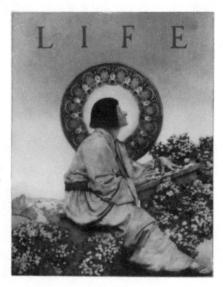

LIFE

1917, September 13 / \$40-\$60 Advertisement in color for Fisk Tires "The Modern Magic Shoes" (See "Posters")

LIFE

1917, November 6 / \$40-\$60 Advertisement for Fisk Tires

LIFE

1918, May 16 / \$45-\$60 Advertisement in color for Fisk Tires "Fit for a King" (See "Magazines" this section)

LIFE

1919, November 6 / \$40-\$60 Advertisement for Fisk Tires

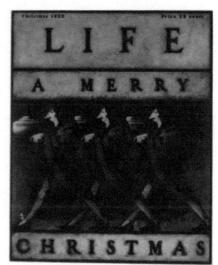

LIFE 1920, December 2 / \$70-\$100 Cover in color "A Merry Christmas"

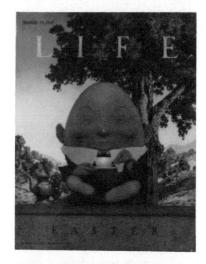

LIFE 1921, March 17 / \$200-\$300 Cover in color for Easter "Humpty Dumpty"

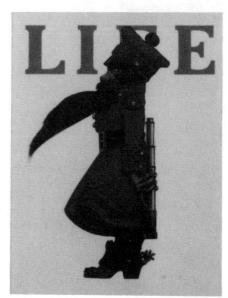

LIFE 1921, June 30 / \$80-\$110 Cover in color "A Swiss Admiral"

LIFE 1921, August 25 / \$80-\$110 Cover in color "Fisherman"

LIFE 1921, October 13 / \$90-\$120 Cover in color "Evening" (See "Prints")

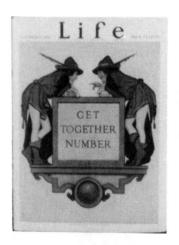

LIFE 1921, November 10 / \$60-\$80 Cover in color, Get Together Number

LIFE 1921, December 1 / \$90-\$110 Cover in color "Christmas Life"

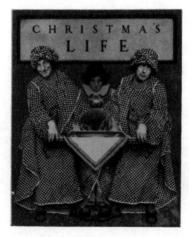

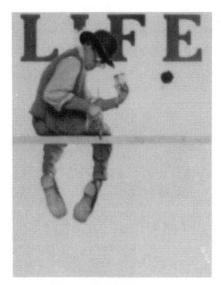

LIFE 1922, January 5 / \$80-\$110 Cover in color "A Man of Letters"

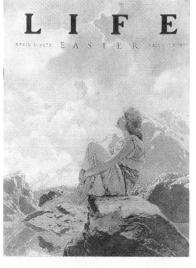

LIFE 1922, May 11 / \$70-\$90 Cover in color, Bookstuff Number Proof shown here

LIFE 1922, June 22 / \$80-\$100 Cover in color "He is a rogue indeed who..."

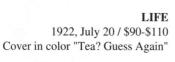

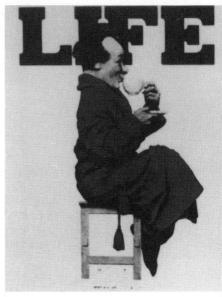

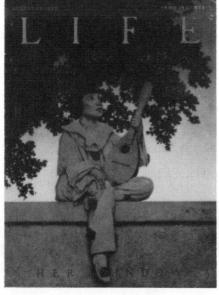

1922, August 24 / \$85-\$100 Cover in color "Her Window"

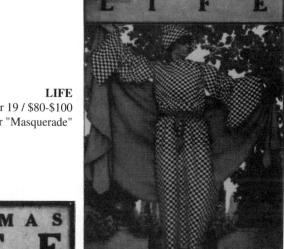

1922, October 19 / \$80-\$100 Cover in color "Masquerade"

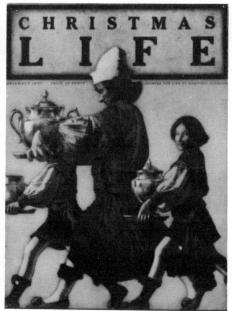

LIFE 1922, December 7 / \$90-\$120 Cover in color "Christmas Life"

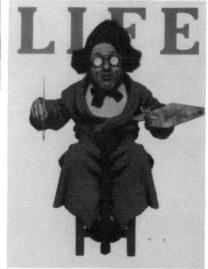

LIFE 1923, March 1 / \$90-\$110 Cover in color "A Dark Futurist"

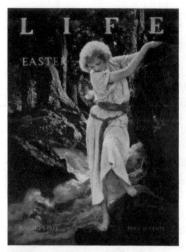

LIFE 1923, March 29 / \$100-\$120 Cover in color "Easter"

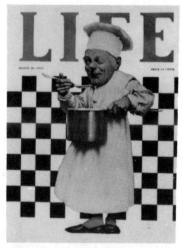

LIFE 1923, August 30 / \$85-\$100 Cover in color

LITERARY DIGEST

1918, May 11 / \$20-\$25 Advertisement in black and white for Fisk Tires "Fit for a King"

LITERARY DIGEST

1936, February 22 / \$15-\$25 Three illustrations in black and white for "Parrish's Magical Blues"

MAGAZINE OF LIGHT

1931, February / \$120-\$180 Cover in color "The Waterfall" (See "E.M. Calendars")

MAGAZINE OF LIGHT

1932, June / \$120-\$190 Cover in color "Sunrise" (See "E.M. Calendars")

McCALL'S

1922, March / \$60-\$80 Advertisement in color for Jello "The King and Queen"

McCLURE'S

1904, November / \$80-\$120 Cover in color from the story "The Rawhide" Also contains a black and white illustration of the cover

McCLURE'S

1904, December / \$30-\$40 Illustration in color from the story "The Rawhide"

McCLURE'S

1905, January / \$50-\$60 Permanent cover design Also used in 1906 and 1907

THE MENTOR

1914, September / \$20-\$30 Three illustrations in black and white from the Florentine Fete murals

THE MENTOR

1922, March / \$60-\$75
Five illustrations in color from the book
The Arabian Nights "The Fisherman and
the Genie," "Prince Codad," "The King of
the Black Isles," "Cassim in the Cave,"
and "The City of Brass"

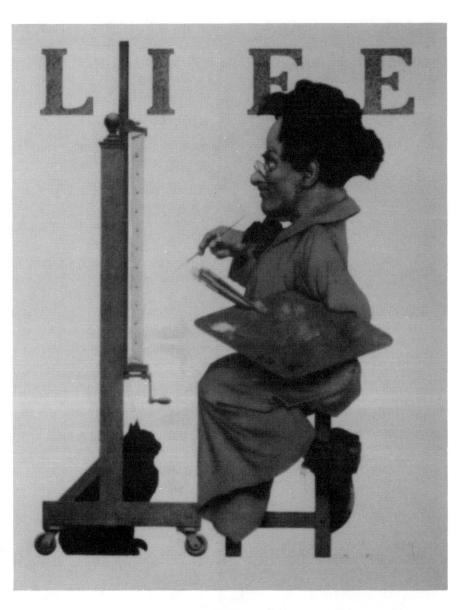

LIFE 1924, January 31 / \$85-\$100 Cover in color "A Good Mixer"

METROPOLITAN MAGAZINE 1917, January / \$125-\$175 Cover in color

NEW HAMPSHIRE TROUBADOUR 1938 Yearbook / \$45-\$65 Cover in color "Thy Templed Hills"

THE MENTOR

1927, June / \$10-\$15 Illustration in black and white "Prince Agib from the book *The Arabian Nights*

METROPOLITAN MAGAZINE

1904, December / \$10-\$15 Illustration in black and white "Once Upon a Time"

METROPOLITAN MAGAZINE

1906, January / \$10-\$15 Illustration in black and white "The Finest Song"

MODERN PRISCILLA

1924, January / \$60-\$90 Back cover advertisement in color for Jello "The King and Queen"

NATION'S BUSINESS

1923, June 5 / \$25-\$30 Illustration in color "The Spirit of Transportation" (See "Prints")

NEW ENGLAND HOMESTEAD

1897, January 2 / \$25-\$40 Cover in black and white "Happy New Year Prosperity"

NEW HAMPSHIRE TROUBADOUR

1938, April / \$15-\$20 Illustration in black and white "Land of Scenic Splendor"

NEW HAMPSHIRE TROUBADOUR

1939 World's Fair Edition / \$50-\$60 Cover in color "Thy Templed Hills" Same as previous entry

NEW HAMPSHIRE TROUBADOUR

1940, February / \$50-\$70 Cover in color "Winter Paradise"

NEW HAMPSHIRE TROUBADOUR

1940 Yearbook / \$50-\$70 Front cover, inside front cover and first page

NEWSWEEK

1935, September 28 / \$10-\$15 Illustration in black and white "Old King Cole" (St. Regis)

OUTING

1900, June / \$60-\$100 Permanent cover design in black and white with colored borders

Permanent cover design used for numerous issues with and without color changes in the borders (Original proof is shown here.)

OUTING

1906, September / \$40-\$60 Example of permanent cover design (See previous entry.)

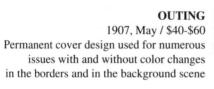

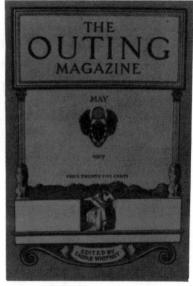

OUTING

1907, November / \$40-\$60 Example of permanent cover design (See previous entry.)

THE OUTLOOK

1899. December / \$15-\$20 Illustration in black and white "The Roman Road"

THE OUTLOOK

1904, December / \$20-\$30 Two illustrations in black and white "The Fly-Away Horse" and "The Sugar-Plum Tree"

PENCIL POINTS

1935, October / \$10-\$15 Illustration in black and white "Old King Cole" (St. Regis)

PICTORAL REVIEW

1924, February / \$60-\$90 Advertisement in color "Polly Put the Kettle On"

THE POSTER

1899, March / \$70-\$100 Advertisement in black and white for Adlake Camera (See "Posters")

PROGRESSIVE FARMER

1952, June / \$40-\$60 Cover in color "Thunderheads"

RED LETTER

1896, December / \$40-\$55 Illustration in black and white "Humpty Dumpty"

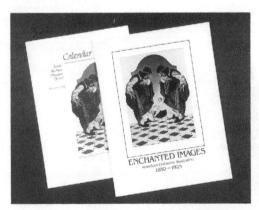

SANTA BARBARA MUSEUM OF ART 1980 / \$15-\$25

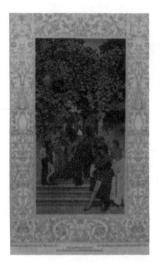

SATURDAY EVENING POST

1913, November 22 / \$20-\$40 Subscription advertisement in black and white for free reproduction of "Buds Below the Roses" from the Florentine Fete murals

SATURDAY EVENING POST

1918 / \$35-\$65 Advertisement in black and white

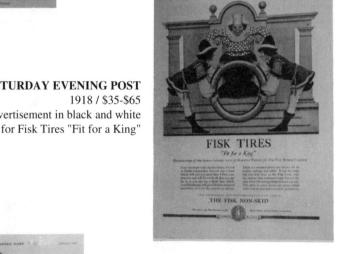

SATURDAY EVENING POST

1918, December 7 / \$40-\$50 Advertisement in color for Community Plate

SATURDAY EVENING POST

1920, January 3 / \$20-\$30 Advertisement in black and white "Prometheus" (See "E.M. Calendars")

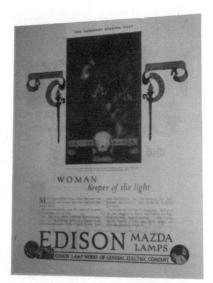

SATURDAY EVENING POST

1921, January 8 / \$50-\$75 Advertisement in color "Primitive Man" (See "E.M. Calendars")

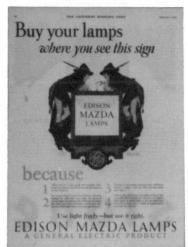

SATURDAY EVENING POST

1925, February 7 / \$35-\$45 Advertisement in color for Edison Mazda Used numerous times during the 1920s

SATURDAY EVENING POST

1925, July 4 / \$15-\$25 Advertisement in sepia for Maxwell House Coffee "The Broadmoor Hotel"

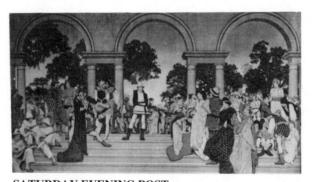

SATURDAY EVENING POST

1925, December 5 / \$65-\$85 Advertisement in color "A Florentine Fete"

SATURDAY EVENING POST

1974, December / \$20-\$35 Cover and article

SCRIBNER'S

1897, August / \$50-\$65 Twelve illustrations in black and white Story title "Its Walls Were as of Jasper"

SCRIBNER'S

1897, December / \$125-\$175 Cover in color

SCRIBNER'S

1897, December / \$60-\$90 Back cover advertisement in color for Royal Baking Powder

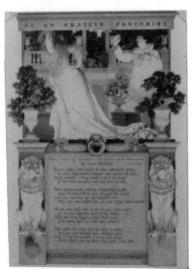

SCRIBNER'S

1898, November / \$15-\$25 Illustration in black and white "At an Amatuer Pantomime"

1898, December / \$45-\$60 Sixteen illustrations and border designs in black and white and color from "The Rape of the Rhine-Gold"

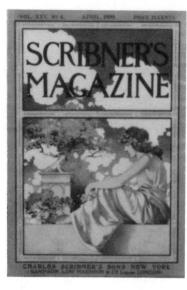

SCRIBNER'S 1899, August / \$90-\$120 Cover in color

1899, October / \$80-\$120

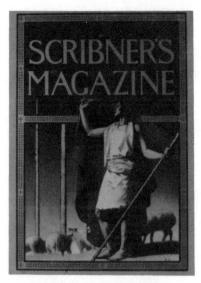

SCRIBNER'S 1899, December / \$75-\$110 Cover in color

SCRIBNER'S

1900, August / \$20-\$25 Four illustrations in black and white One headpiece in black and white

SCRIBNER'S 1900, October / \$75-\$110 Cover in color

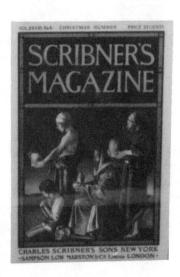

SCRIBNER'S 1900, December / \$75-\$110 Cover in color

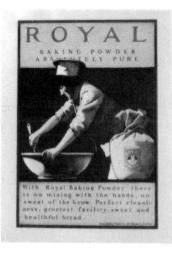

SCRIBNER'S

1900, December / \$50-\$70 Back cover advertisement in color for Royal Baking Powder

SCRIBNER'S

1901, August / \$40-\$65 Seven illustrations, a headpiece and tailpiece in black and white and color from "Phoebus on Halzaphron"

SCRIBNER'S 1901, December / \$80-\$100 Cover in color

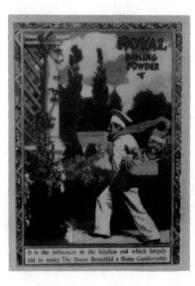

SCRIBNER'S

1901, December / \$55-\$75 Back cover advertisement in color for Royal Baking Powder

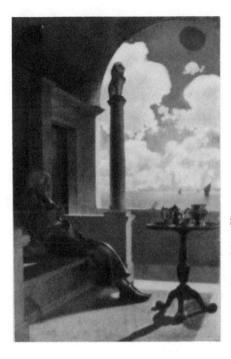

SCRIBNER'S
1901, December / \$35-\$45
Frontispiece in color
"The Cardinal Archbishop"
Also two illustrations in black and white

SCRIBNER'S 1902, December / \$25-\$30 Frontispiece in color "The Desert"

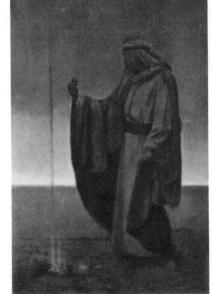

SCRIBNER'S

1903, July / \$25-\$35 Frontispiece in color "Aucassin Seeks for Nicolette" (See "Prints")

SCRIBNER'S

1903, December / \$25-\$40 Frontispiece in color "Venitian Night's Entertainment" Also two headpieces in black and white

SCRIBNER'S 1904, October / \$80-\$100 Cover in color

SCRIBNER'S 1904, December / \$25-\$35 Frontispiece in color "The Vigil-At-Arms"

SCRIBNER'S 1905, August / \$25-\$50 Frontispiece in color "Potpourri"

Frontispiece in color "Old Romance"

SCRIBNER'S

1910, August / \$35-\$45 Frontispiece in color "The Errant Pan" (See "Prints")

SCRIBNER'S

1912, August / \$30-\$40 Frontispiece in color "Land of Make-Believe" (See "Prints")

SCRIBNER'S 1923, August / \$90-\$100 Cover in color

SCRIBNER'S

1937, January / \$30-\$45 50th Anniversary Number Illustration in color "The Errant Pan" (See "Prints")

ST. NICHOLAS

1898, December / \$15-\$20 Frontispiece in black and white "Sunny Provence"

ST. NICHOLAS

1900, November / \$10-\$15 Illustration in black and white "A Quarter Staff Fight"

ST. NICHOLAS

1903, December / \$15-\$20 Illustration in black and white from the story "The Three Caskets"

ST. NICHOLAS

1910, November / \$15-\$20 Illustration in black and white "The Sandman"

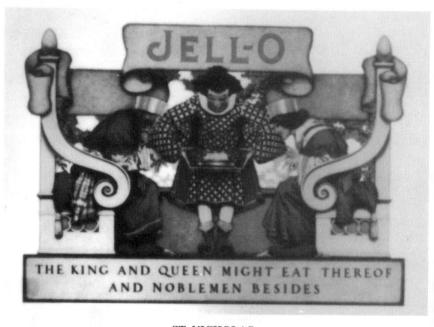

ST. NICHOLAS

1922, March / \$55-\$70 Advertisement in color for Jello "The King and Queen"

SUCCESS 1901, December / \$80-\$120 Cover in color

SUCCESSFUL FARMING 1925, May / \$25-\$40 Advertisement in color

SURVEY 1929, August 1 / \$10-\$15 Illustration in black and white

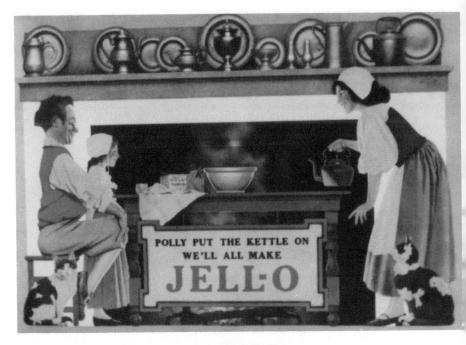

VANITY FAIR

1922, February / \$55-\$70 Advertisement in color for Jello "Polly Put the Kettle On"

WOMAN'S HOME COMPANION

1921, April / \$70-\$90 Advertisement in color for Ferry Seeds "Peter Piper" (See "Posters")

THE WORLD'S WORK

1918, February / \$80-\$110 Advertisement in color "And Night Is Fled" (See "E.M. Calendars")

THE WORLD'S WORK

1921, June / \$35-\$45 Advertisement in color for Hires Root Beer (See "Posters")

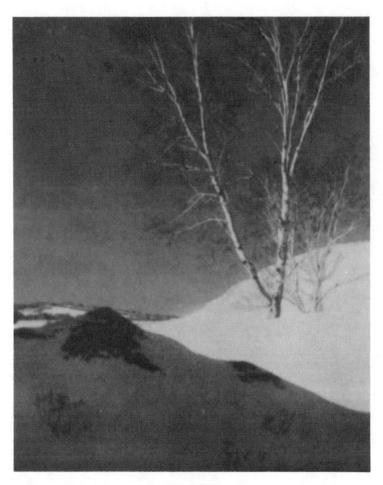

YANKEE 1935, December / \$40-\$60 Cover in color "White Birch in Winter"

YANKEE 1968, December / \$25-\$35 Cover "Church, Norwich, Vermont"

YANKEE 1977, May / \$20-\$30 Cover "The Gardener"

YOU AND YOUR WORK 1944, May 13 / \$45-\$65 Cover "Tranquility"

YOUTH'S COMPANION

1919, February 20 / \$70-\$90 Advertisement in color for Ferry Seeds "Peter, Peter"

YOUTH'S COMPANION

1924, January 3 / \$55-\$70 Advertisement in color for Jello "Polly Put the Kettle On"

POSTERS & ADVERTISEMENTS

"...while trying to bring down a mosquito at 11.04 Saturday night, I was wondering how it would do for the seed poster, to dilate upon the theme of 'Peter, Peter, pumpkin eater'....This was not my original idea at all, but maybe you know yourself how one mosquito may drive you to almost any length."

Maxfield Parrish August 6, 1917

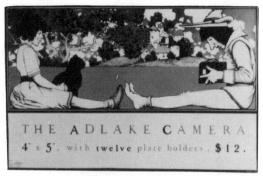

ADLAKE CAMERA 1897 / \$1800-\$2200 Poster The Adlake Camera 11 1/4" X 17"

AMERICAN WATER COLOR SOCIETY

1899 / \$1700-\$2000 Poster Exhibition of the American Water Color Society Now Open at the National Academy of Design 14" X 22"

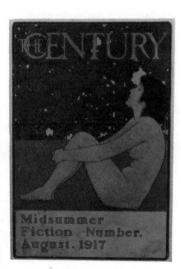

CENTURY MAGAZINE

1897 / \$850-\$1200 Poster Midsummer Fiction or Holiday Number Several reprints were made, 1917 shown here 14" X 20"

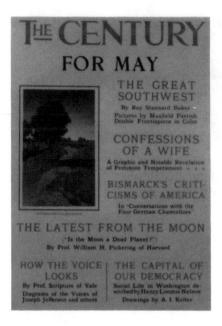

CENTURY MAGAZINE 1902 / \$1100-\$1500 Poster An Irrigation Canal 14" X 20"

COLGATE AND COMPANY

1897 / \$2200-\$2500 Poster The Dutch Boy 15" X 20"

COLLIER'S MAGAZINE

1907 / \$2250-\$2500 "Toyland" Toy Show (See "Magazines") 22" X 28"

COLUMBIA BICYCLES

1896 / \$2000-\$2400 Poster Male Bicyclist 12 1/2" X 20" (See "Magazines")

COLUMBIA BICYCLES

1896 / \$2000-\$2400 Poster Female Bicyclist 12 1/2" X 20" (See "Magazines")

COPELAND AND DAY PUBLISHERS

1897 / \$1500-\$1800 Poster "Free to Serve" A man standing in front of a fireplace bearing a sign "Emma Rayner"

DJER-KISS COSMETICS

1916 / \$750-\$1000 Window display advertisement Girl in a swing (See "Magazines")

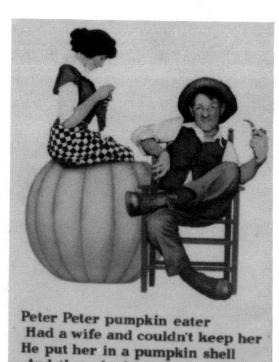

And there he kept her very well

D.M. FERRY COMPANY 1918 / \$1100 - \$1300 Poster "Peter, Peter"

D.M. FERRY COMPANY 1919 / \$1100-\$1300 Poster "Peter Piper" 17 1/2" X 22 1/2"

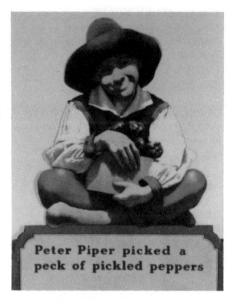

D.M. FERRY COMPANY 1921 / \$1100-\$1300 Poster "Mary Mary" 18" X 19 1/2" (image only)

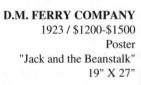

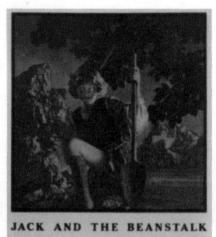

PLANT FERRY'S SEEDS

FIRST EXHIBITION OF ORIGINAL WORKS 1925 / \$200-\$300 Advertising handout 4 1/2" X 5 3/8"

FISK RUBBER COMPANY

1917 / \$800-\$1000 Window display advertisement "Fit for a King" (See "Magazines")

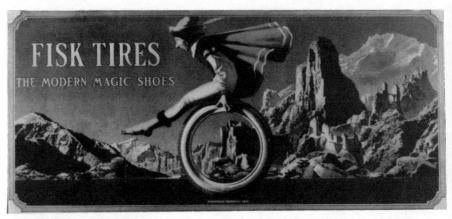

FISK RUBBER COMPANY

1917 / \$900-\$1200 Window display advertisement "The Modern Magic Shoes" 13" X 28 1/2"

FISK RUBBER COMPANY

1919 / \$900-\$1100 Window display advertisement "The Magic Circle" 5" X 10 3/4"

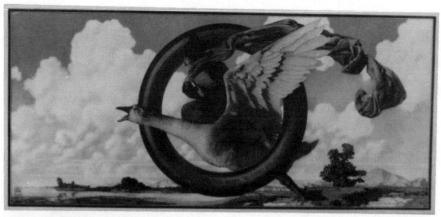

FISK RUBBER COMPANY 1919 / \$900-\$1200

Window display advertisement "Mother Goose" 9 1/2" X 20 1/2"

FISK RUBBER COMPANY

1920 / \$850-\$1200 Wallpaper frieze "Mother Goose"

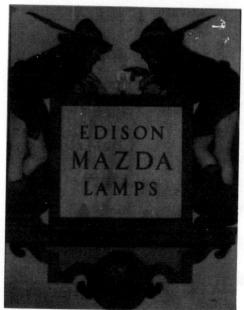

GENERAL ELECTRIC

1920s / \$600-\$750 Countertop easel display advertisement Edison Mazda, Parrish-designed logo 8" X 10"

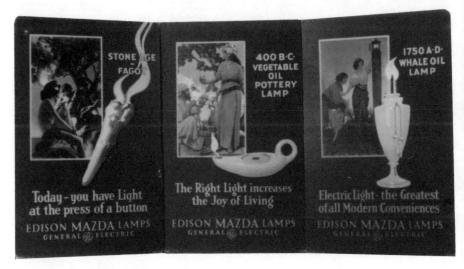

GENERAL ELECTRIC

1929 / \$700-\$900 each Countertop easel display advertisement Edison Mazda Lamp Division displaying the evolution of light. A series of eight in which three are Parrish Set of all 8 / \$2800-\$3000

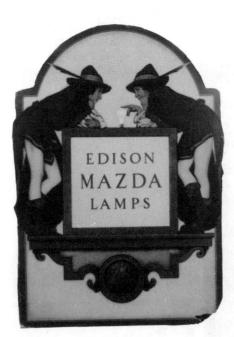

GENERAL ELECTRIC 1920s / \$2200-\$2600 Window display sign Edison Mazda, Parrish-designed logo 34" X 47"

GENERAL ELECTRIC 1920s / \$1600-\$2000 Life-size advertisement Edison Mazda Lamp Division 62" high

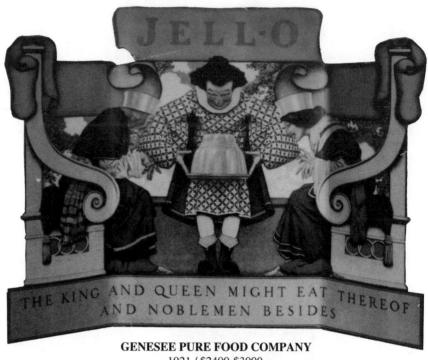

1921 / \$2400-\$3000 Stand-up advertisement Jello "The King and Queen" 29 1/4" X 41 1/4"

HARPER'S WEEKLY 1897 / \$1800-\$2000 National Authority on Amateur Sport 12 1/4" X 16"

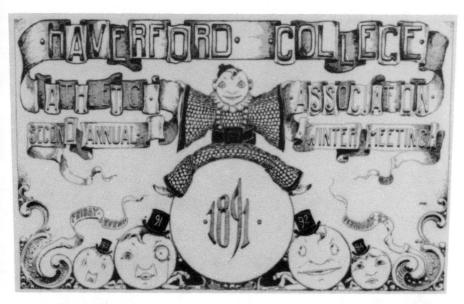

HAVERFORD COLLEGE

1891 / \$800-\$1100 Poster/Announcement Athletic Association Second Annual Winter Meeting 4" X 6 1/2"

HELIOTYPE PRINTING COMPANY 1896 / \$2000-\$2400 Poster "Child Harvester" 26 1/2" X 42"

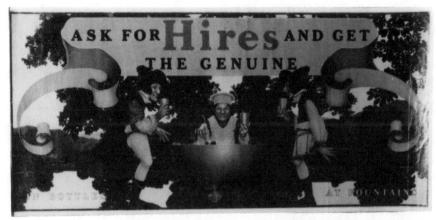

CHARLES E. HIRES COMPANY

1920 / \$900-\$1100

Window display advertisement "Ask for Hires" 12 1/2" X 20"

HORNBY'S OATMEAL

1896 / \$2000-\$2300 Poster

"Hornby's Oatmeal" 28" X 42 1/2"

NEW HAMPSHIRE PLANNING AND DEVELOPMENT COMMISSION

1938 / \$700-\$900

Poster

"New Hampshire" 18" X 21"

All this is yours to enjoy . **NEW HAMPSHIRE**

1942 / \$45-\$55 Vacation booklet advertisement

NEW HAMPSHIRE PLANNING AND DEVELOPMENT COMMISSION

1936 / \$700-\$900

Poster

"Thy Templed Hills" (See "B & B Calendars")

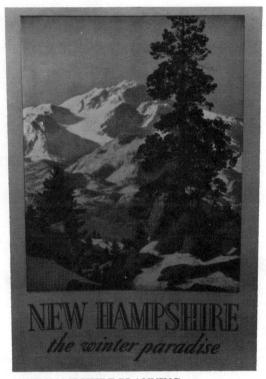

NEW HAMPSHIRE PLANNING AND DEVELOPMENT COMMISSION 1939 / \$750-\$1000 Poster "Winter Paradise" 21" X 31"

NO-TO-BAC 1896 / \$1750-\$2000 Poster "No-To-Bac"

NOVELTY BAZAAR COMPANY

1908 / \$1400-\$1600

Poster

"Toy Show and Christmas Present Bazaar"

PENNSYLVANIA ACADEMY OF THE FINE ARTS

1896 / \$2000-\$2500

Poster

"Poster Show Exhibition"

PHILADELPHIA HORSE SHOW ASSOCIATION

1896 / \$2000-\$2400

Poster

"Fifth Annual Open-Air Exhibition"

R.H. RUSSELL PUBLISHING

1899 / \$1500-\$1800

Poster

"Knickerbocker's History of New York" 16" X 24 1/2"

SCRIBNER'S MAGAZINE 1897 / \$2000-\$2400 Poster "The Christmas Scribner's" 15" X 22"

SCRIBNER'S MAGAZINE

1897 / \$1700-\$2100

"Scribner's Fiction Number August" 14 1/4" X 19 3/4"

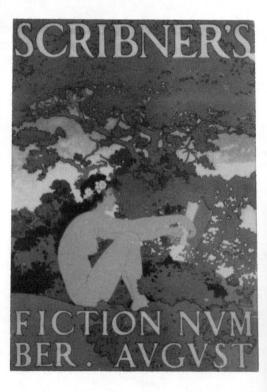

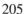

Two illustrated poems for the Easter Season A Newspaper Story by Jesse Lynch Williams Illustrated – And other features SCRIBNER'S MAGAZINE 1899 / \$950-\$1250 Poster

Scribner's April Cover 14" X 22"

SWIFT AND COMPANY 1919 / \$750-\$900

Poster "Jack Sprat" 15" X 20"

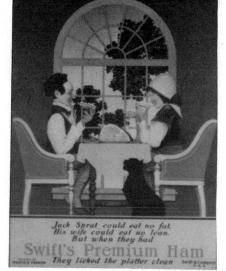

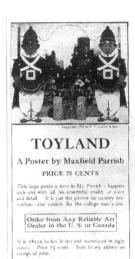

Address PRINT DEPT. P. F. Coilier & Son, 416 W. 13th St., New York **TOYLAND** 1908 / \$70-\$100 Poster Advertisement

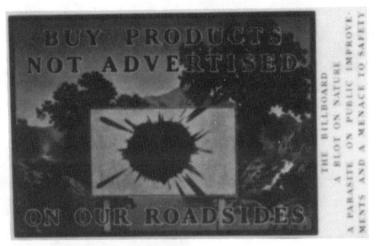

VERMONT ASSOCIATION FOR BILLBOARD RESTRICTION

1939 / \$700-\$900

Poster

"Buy Products Not Advertised

On Our Roadside"

WELLSBACH LIGHT

1896 / \$2100-\$2500

Poster

"The Improved Wellsbach Light"

ILLUSTRATED PROGRAMS & RELATED

"I'm no earthly good at the little telling sketch: the few strokes of the pencil were never my medium: could'nt (sic) even make a drawing on the Player's Club table cloths."

Maxfield Parrish November 27, 1923

A SELECTED LIST OF NEW BOOKS FOR THE HOLIDAYS

1905 / \$170-\$225 Scribner's catalog cover

BRYN MAWR COLLEGE

1891 / \$300-\$375 Program cover in color Bryn Mawr College Lantern

BRYN MAWR COLLEGE

1891 / \$300-\$375 Theatrical program cover in color

BRYN MAWR COLLEGE

1894 / \$300-\$375

Theatrical program cover in color

THE DREAM GARDEN 1915 / \$50-\$60 Pamphlet

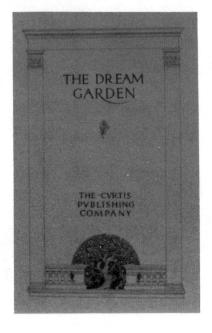

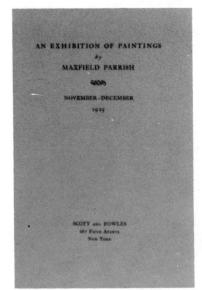

EXHIBITION OF PAINTINGS 1925 / \$70-\$90 Pamphlet

D.M. FERRY COMPANY 1919 / \$190-\$270 Seed Annual catalog cover

HAVERFORD COLLEGE

1892 / \$275-\$350

Cover

Haverford College Grammar School

HAVERFORD COLLEGE

1898 / \$250-\$325

Cover

Haverford College Athletic Annual

HAVERFORD COLLEGE

1908 / \$225-\$300

Cover

Haverford Verse

HOWARD HART PLAYERS

1917 / \$250-\$290

Program cover

MASK AND WIG CLUB 1895 / \$300-\$400 Theatrical program cover

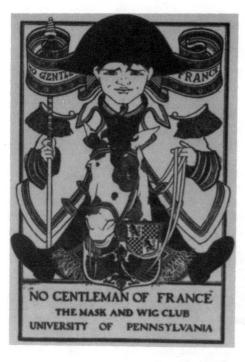

MASK AND WIG CLUB 1896 / \$350-\$450 Theatrical program cover "No Gentleman of France"

MASK AND WIG CLUB

1897 / \$300-\$400 Theatrical program cover "Very Little Red Riding Hood"

MASK AND WIG CLUB

1898 / \$300-\$375 Program cover "1889-1898 Decennial Anniversary of the Mask and Wig Club"

PENNSYLVANIA ACADEMY OF THE FINE ARTS

1897 / \$300-\$340 Program in color "Fellowship Ball"

PENNSYLVANIA STATE COLLEGE

1892 / \$300-\$375 Class book

PHILADELPHIA BOURSE

1895 / \$320-\$390 Catalog cover

SCRIBNER BOOKS FOR YOUNG READERS

1905 / \$200-\$275 Catalog cover

SCRIBNER'S NEW BOOKS FOR THE YOUNG 1899 / \$250-\$350 Catalog cover

STERLING CYCLE WORKS

1897 / \$290-\$380 Sterling Bicycles Catalog cover

WANAMAKER'S

1895 / \$320-\$380 Holiday catalog cover

WANAMAKER'S

1896 / \$300-\$380 Summer catalog cover

WEST CHESTER CRICKET CLUB 1891 / \$325-\$375 Playbill "Our Boys"

MISCELLANEOUS MAGAZINES & CALENDARS

"I wish to Heaven I had a profession that was taken seriously, say, that of a dentist."

Maxfield Parrish May 24, 1924

MISCELLANEOUS MAGAZINES

P.F. COLLIER & SON

Various headpieces designed by Parrish and used frequently during the first quarter of the 20th century \$10-\$20 each

Headpieces continued from previous page

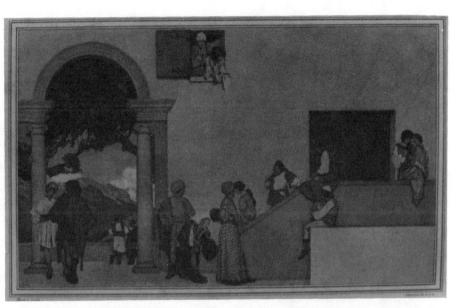

SATURDAY EVENING POST \$200-\$275 Gift certificate for subscription "Castle of Indolence" from the Florentine Fete murals

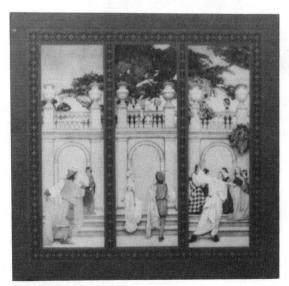

SATURDAY EVENING POST \$250-\$300 Subscription card Three of the Florentine Fete murals

BROWN & BIGELOW

Miscellaneous Calendars

MASTERPIECES

1956 / \$80-\$100

Six landscapes in color:

"An Ancient Tree"

"Daybreak"

"Evening"

"Evening Shadows"

"Sunup"

"Thy Rocks and Rills"

MY HOMELAND

1964 / \$75-\$95

Six landscapes in color:

"A Perfect Day"

"New Moon"

"Peaceful Valley"

"Sheltering Oaks"

"Sunlight"

"The Mill Pond"

OUR BEAUTIFUL AMERICA

1942 / \$100-\$150

"Peaceful Valley"

"Twilight"

"The Village Brook"

"Thy Templed Hills"

DODGE PUBLISHING

Miscellaneous Calendars All calendars measure 6" X 8" / \$75-\$100 each With box / \$90-\$120 each

CALENDAR OF SUNSHINE

1916 "Harvest" (See "Prints")

BUSINESS MAN'S CALENDAR

1917 "Thanksgiving" (See "Prints")

BUSINESS MAN'S CALENDAR

1921 "Wassail Bowl"

CALENDAR OF FRIENDSHIP 1922

"Search for the Singing Tree"

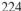

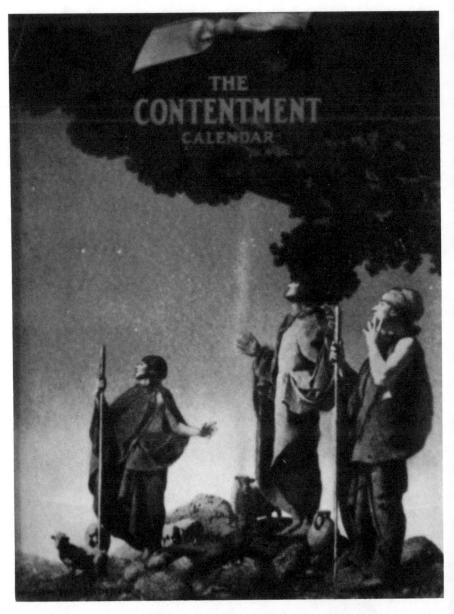

CONTENTMENT CALENDAR 1922 "Three Shepherds"

CALENDAR OF SUNSHINE 1924 "Prince Agib"

SUNLIT ROAD CALENDAR 1924 "Queen Gulnare"

BUSINESS MAN'S CALENDAR 1925

"The Landing of the Brazen Boatman" (See "Prints")

CALENDAR OF FRIENDSHIP

1925 "Jason and the Talking Oak" (See "Prints")

CONTENTMENT CALENDAR 1925 "Prince Agib" (See "Prints")

SUNLIT ROAD CALENDAR 1925 "Land of Make-Believe"

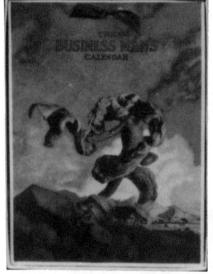

BUSINESS MAN'S CALENDAR 1926 "Cadmus Sowing the Dragon's Teeth"

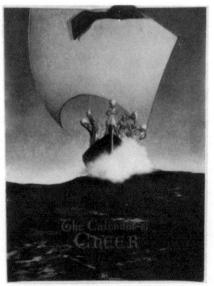

CALENDAR OF CHEER 1926 "Prince Codadad"

CALENDAR OF CHEER

1926 "Prince Codadad" with presentation box

CALENDAR OF FRIENDSHIP

1926 "Circe's Palace" (See "Prints")

CALENDAR OF SUNSHINE

1926 "Harvest" (See "Prints")

CONTENTMENT CALENDAR

1926 "Summer"

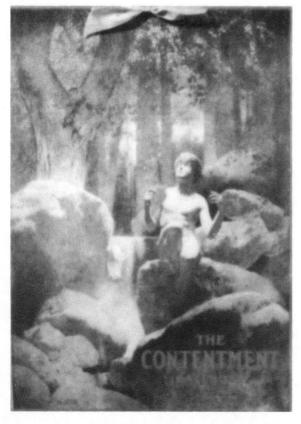

SUNLIT ROAD CALENDAR

1926

"Fountain of Pirene"

(See "Prints")

BUSINESS MAN'S CALENDAR

1927

"Ouest for the Golden Fleece" (See "Prints")

CALENDAR OF CHEER

1927

"Lantern Bearers" (See "Prints")

CALENDAR OF FRIENDSHIP

"Jason and the Talking Oak" (See "Prints")

CONTENTMENT CALENDAR

1927

"Land of Make-Believe" (See "Prints")

SUNLIT ROAD CALENDAR

1927

"Prince Agib"

(See "Prints")

DESK EASEL CALENDARS

1916-1927 / \$60-\$90 each From the books "The Arabian Nights," "A Wonderbook and Tanglewood Tales" and "The Golden Treasury of Songs and Lyrics" With brocade, leather covers / \$90-\$120 each

THOMAS D. MURPHY

Miscellaneous Calendars

Known sizes are as follows:

Large complete: 21 1/2" X 45 1/2"

Large cropped: 16 1/2" X 22"

Small complete: 16 1/2" X 22"

Small cropped: 10" X 14"

SUNRISE

1937

Complete Cropped Large \$500-\$650 \$300-\$400 Small \$325-\$400 \$100-\$140

(See "E.M. Calendars")

ONLY GOD CAN MAKE A TREE (GOLDEN HOURS)

1938

Complete Cropped

Large \$450-\$550 \$250-\$350 Small \$275-\$350 \$80-\$110

DREAMING

1939

Complete Cropped Large \$500-\$600 \$300-\$350 Small \$300-\$400 \$100-\$125

ROCK OF AGES (ARIZONA)

1939

Cropped Complete Large \$400-\$500 \$225-\$300 Small \$250-\$300 \$75-\$100

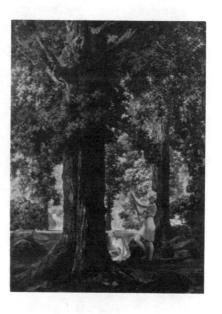

WHEN WINTER COMES (WHITE BIRCH)

1941

Complete Cropped

Large \$400-\$475 \$225-\$275 Small \$225-\$275 \$60-\$90

(See "Prints")

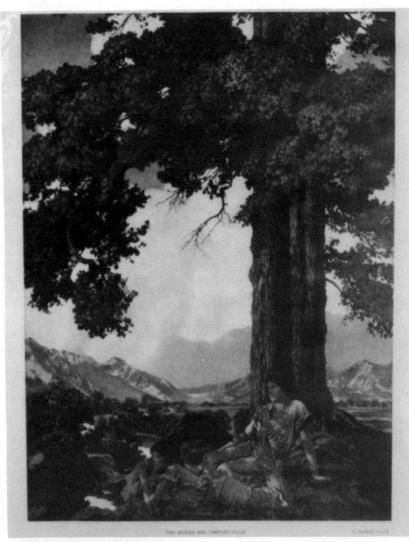

THY WOODS AND TEMPLED HILLS (HILL TOP)

1942

Complete Cropped Large \$550-\$650 \$350-\$425 \$mall \$350-\$425 \$100-\$150

CHARLES SCRIBNER'S SONS

Miscellaneous Calendars

PANDORA 1919 / \$325-\$425 (See "Prints")

PROSERPINA AND THE SEA NYMPHS 1919 / \$300-\$400 (See "Prints")

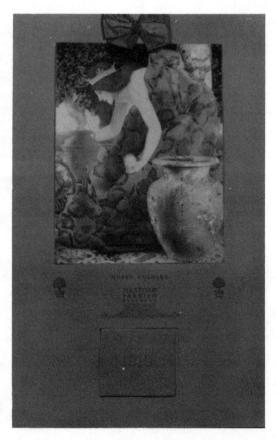

QUEEN GULNARE 1919 / \$300-\$400

STORY OF A KING'S SON 1919 / \$300-\$375 (See "Prints")

MISCELLANEOUS CALENDARS

THE CALENDAR OF KIPLING'S BALLAD 1918 / \$175-\$225

Alternating pages contain one or two comic sold

COLGATE & COMPANY 1902 / \$175-\$250 Pocket calendar

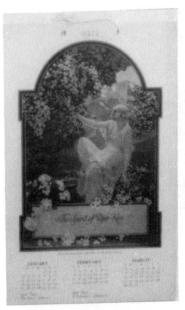

DJER-KISS 1925 / \$300-\$450 Wall calendar

DODGE PUBLISHING COMPANY

1906-1912 / \$50-\$70 Various desk top calendars from book illustrations All have easel backs

EDISON MAZDA

1918-1934 / \$80-\$100 Wallet calendars in celluloid One for each year

MISCELLANEOUS SPIN-OFFS

"It isn't a sketch - it's a peach! - and I heartily congratulate you. I am sending the sketch over now to Mr. Tiffany to see if he will render it into glass. Of course, it is a delicate matter, because not only must I turn down his sketch, but on top of that ask him to render another man's work."

Edward Bok Ladies' Home Journal February 11, 1914 To M.P. regarding "The Dream Garden"

EDISON MAZDA LAMPS

EDISON LIGHT & POWER CO., 41 W. Market St., York, Pa.

BLOTTER 1924 / \$75-\$125 Edison Mazda

BOOK MATCHES

1920s / \$5 "The Broadmoor Hotel"

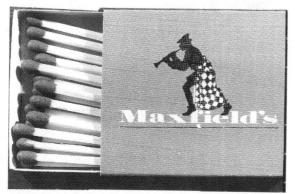

BOOK MATCHES 1930s / \$10 Maxfield's

BUSINESS CARDS

1920s-1930s / \$35-\$50 Edison Mazda Division of G.E. 3 1/4" X 6 3/4"

CRANE'S CHOCOLATES RETAIL STORE Late 1910s

CRANE'S CHOCOLATE BOX 1916 / \$275-\$350 "Rubaiyat" (See "Prints")

CRANE'S CHOCOLATE BOX 1917 / \$275-\$360

"Cleopatra" (See "Prints")

CRANE'S CHOCOLATE BOX

1917 / \$290-\$325 Crane's logo of a crane (See Tin - Crane's Chocolates Sign this section)

CRANE'S CHOCOLATE BOX 1918 / \$300-\$350

"Garden of Allah" (See "Prints")

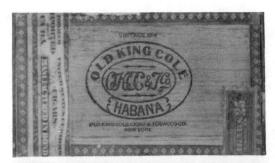

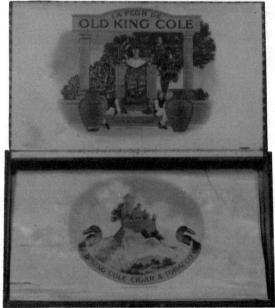

CIGAR BOX 1914 / \$450-\$550 "Old King Cole"

THE SHERMAN

QUALITY THE SHERMAN TAMPA, CIGARS THE SHERMAN FLA.

CIGAR BOX (LABEL) 1927 / \$550-\$650 "The Sherman"

FILM/VIDEO CASSETTE

"Parrish Blue" 25 minutes in color Film / \$350-\$400 Video cassette / \$250-\$300

GAME
1913 / \$1200-\$1500
"Maxfield Parrish Soldier"
Parker Brothers
The Soldier's head drops behind his body when shot with the (included) air rifle.

TOY SOLDIER (OUT OF THE BOX) Head is on a spring and rocks back and forth when hit with dart

(See previous entry)

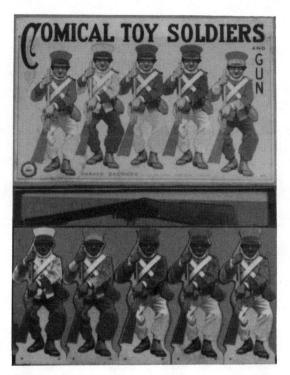

GAME 1921 / \$1200-\$1500 "Comical Toy Soldiers" Parker Brothers

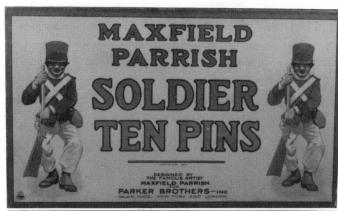

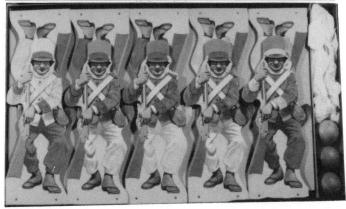

GAME 1921 / \$1000-\$1300 "Soldier Ten Pins" Parker Brothers

GESSO AND WOOD WALL PLAQUE 1920s / \$100-\$130 "Reveries"

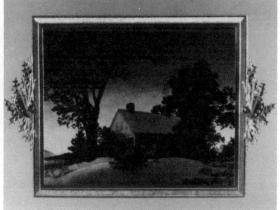

GREETING CARDS 1936-1963 / \$30-\$50 each Brown & Bigelow Landscape and winter scenes "At Close of Day" (1957) Winter scene shown here (See "B&B Calendars")

GREETING CARDS 1918-1934 / \$95-\$110 each Edison Mazda "Sunrise" (1933) shown here (See "E.M. Calendars")

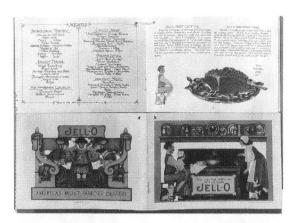

JELLO GELATIN PACKAGE

1920s / \$15-\$25 "Polly Put the Kettle On" (See "Magazines")

JELLO GELATIN PACKAGE 1920s / \$15-\$25

"The King and Queen" (See "Magazines")

JIGSAW PUZZLE 1909-1910 / \$150-\$200 Arabian Nights series from P.F. Collier & Son "Search for the Singing Tree" shown here with box

JIGSAW PUZZLE 1970s / \$50-\$75 "Daybreak" (See "Prints")

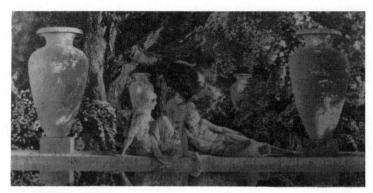

JIGSAW PUZZLE 1920s / \$175-\$225 "Garden of Allah"

JIGSAW PUZZLE Mid 1920s / \$200-\$275 Knave of Hearts "Knave Watches Violetta Depart"

JIGSAW PUZZLE Mid 1920s / \$200-\$280 Knave of Hearts "The Page" (See "Prints")

JIGSAW PUZZLE Mid 1920s / \$200-\$300 Knave of Hearts "The Prince" (See "Prints")

JIGSAW PUZZLE Mid 1920s / \$200-\$275

Knave of Hearts "Lady Violetta and the Knave"

JIGSAW PUZZLE 1913 / \$500-\$700 "Komical Soldier"

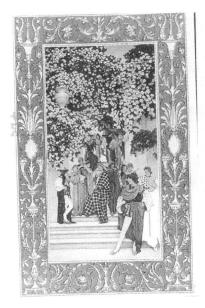

LADIES' HOME JOURNAL 1920s / \$55-\$75 Subscription gift

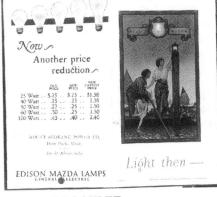

LAMP BOOKLET 1924 / \$35-\$45 Edison Mazda Lamps

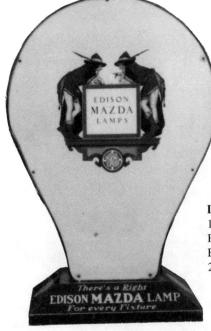

LAMP DISPLAY AND TESTER 1920s / \$2200-\$2500

Bearing the Parrish-designed Edison Mazda logo 23" H

EDISON MAZDA LAMP DISPLAY IN **USE** 1920s

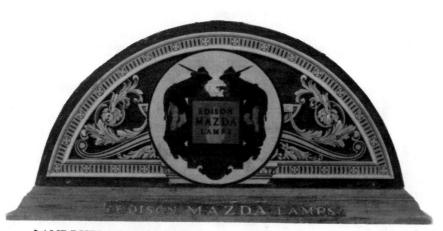

LAMP DISPLAY AND TESTER 1920s / \$1700-\$2000 Bearing the Parrish-designed Edison Mazda logo 13" H

LETTER SEAL 1920s / \$25-\$40 Edison Mazda

LIGHT BULB TIN 1920s / \$95-\$125 Bearing the Parrish-designed Edison Mazda logo

LIPSTICK TISSUE 1920s-1930s / \$10-\$20 "The Broadmoor"

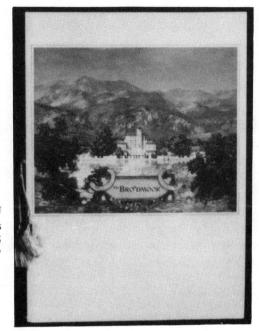

MENU Late 1950s and early 1960s \$150-\$195 "The Broadmoor"

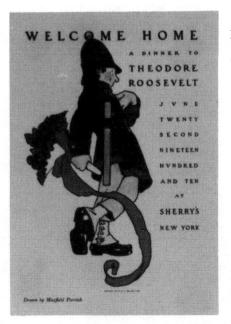

MENU FRONTISPIECE 1910 / \$90-\$125 "Welcome Home"

PLAYING CARDS 1971 / \$75-\$100 full deck Brown & Bigelow "In the Mountains"

PLAYING CARDS

Edison Mazda / Full decks
1918 / \$250-\$300 "And Night is Fled"
1919 / \$275-\$325 "Spirit of the Night"
1922 / \$275-\$325 "Egypt"
1923 / \$250-\$300 "Lamp Seller of Bagdad"
1924 / \$200-\$250 "Venetian Lamplighter"
1926 / \$225-\$275 "Enchantment"
1927 / \$200-\$250 "Reveries"
1928 / \$225-\$275 "Contentment"
1930 / \$225-\$275 "Ecstasy"

1931 / \$225-\$275 "Waterfall"
(See "E.M. Calendars" under each title)

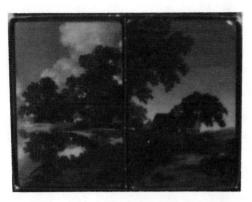

PLAYING CARDS (CANASTA)

1958 / \$100-\$150 Full deck "New Moon" (Right) 1960 / \$100-\$150 Full deck "Sheltering Oaks" (Left) Brown & Bigelow

PLAYING CARDS 1950s / \$80-\$110 "The Broadmoor"

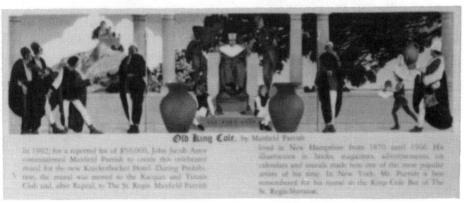

POST CARD Late 1960s / \$20-\$30 "Old King Cole" (St. Regis)

POST CARD 1915 / \$75-\$100 "The Pied Piper"

POST CARD

1920s / \$25-\$35 "The Broadmoor Hotel" (See "Prints")

POST CARD

1939 / \$30-\$40 Vermont Association for Billboard Restriction (See "Posters")

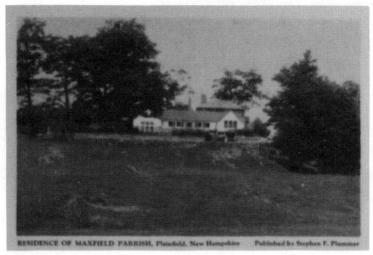

POST CARD 1940s-1950s / \$20-\$30 Residence of Maxfield Parrish

PRINT PORTFOLIO

1917 / \$800-\$950 "A Collection of Colour Prints" by Geurin and M. Parrish "Italian Villas and Their Gardens" Fifteen prints in color, all matted (See "Prints")

PRINT PORTFOLIO

1905 / \$800-\$950 Maxfield Parrish's Pictures in Color "Dinkey-Bird" "Sugar-Plum Tree" "With Trumpet and Drum" "Wynken, Blynken, and Nod" (See "Prints" under each title)

PRINT PORTFOLIO

1906-1908 / \$450-\$550

Maxfield Parrish's Four Best Paintings

"Cassim in the Cave"

"History of the Fisherman

and the Genie"

"King of the Black Isles"

"Prince Codadad"

(See "Prints" under each title)

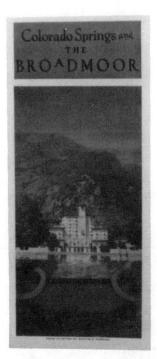

ROOM CARD 1920s / \$55-\$75 "The Broadmoor Hotel" Booklet with room rates

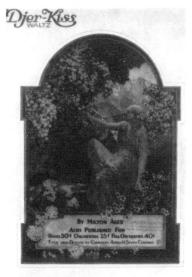

SHEET MUSIC 1925 / \$125-\$175 "Djer-Kiss Waltz"

HANGING PORCELAIN SIGN 1920s / \$1650-\$2250 Edison Mazda Parrish-designed logo Double sided porcelain on metal

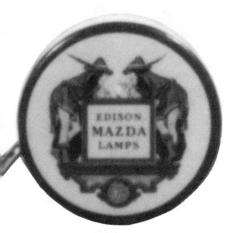

TAPE MEASURE 1920 / \$90-\$110 Edison Mazda Parrish-designed logo

STAMP Early 1900s / \$90-\$140 "Get the Habit"

THERMOMETER Early 1940s / \$125-\$150 Thomas D. Murphy Co. "Arizona"

THERMOMETEREarly 1940s / \$150-\$200
Thomas D. Murphy Co.
"Dreaming"

THERMOMETER Early 1940s / \$130-\$170 Thomas D. Murphy Co. "Golden Hours" (See "E.M. Calendars")

THERMOMETER Early 1940s / \$140-\$180 Thomas D. Murphy Co. "Sunrise" (See "E.M. Calendars")

TIE RACK 1909 / \$300-\$375 Pyraglass Co. "Old King Cole"

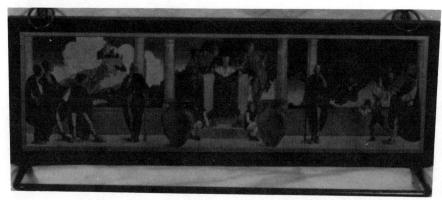

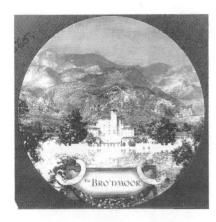

TIN LID 1920s / \$150-\$175 "The Broadmoor"

TIN SIGN 1917 / \$850-\$950 Crane's Chocolates

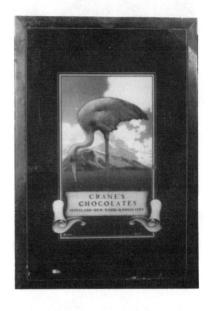

TOBACCO PACKAGE 1920s / \$175-\$250 "Old King Cole"

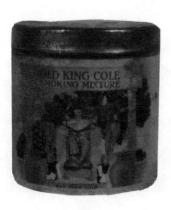

TOBACCO TIN 1920s / \$650-\$750 "Old King Cole"

TOY ADVERTISING DOLL 1929 / \$850-\$1200 General Electric Bandy Doll (Missing small baton)

TOY ADVERTISING DOLL 1926 / \$1200-\$1500 RCA Radiotron "The Selling Fool" (Slits in hands hold business cards)

TRIPTYCH Late 1920s / \$1200-\$1500 Many different combinations of triptychs are known to exist Values are determined by adding the individual print values together plus 10-20% for the triptych frame Example shown here (from left to right):

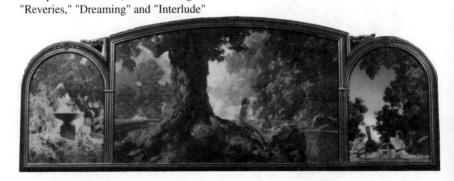

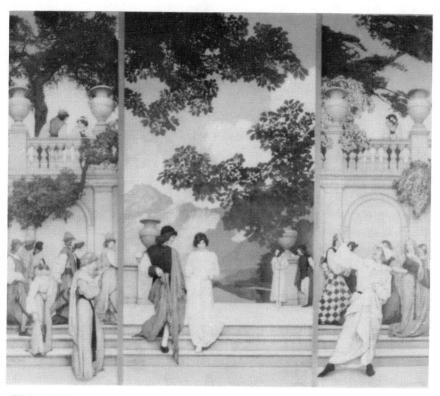

TRIPTYCH 1915 / \$1200-\$1500 Three of the Florentine Fete murals From left to right "Love's Pilgrimage," "Garden of Opportunity" and "A Call to Joy" All printed as one piece, with gold borders surrounding each image 20 1/2" X 24 1/4"

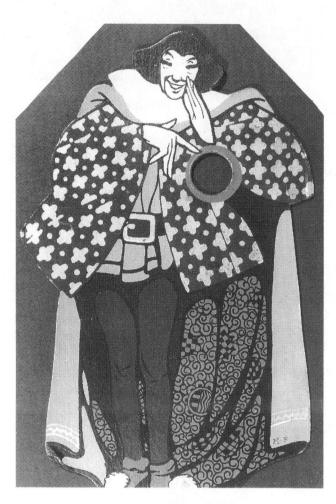

PAINTER'S PALETTE 1900s / \$950-\$1250 Wanamaker Co.

Index

The bold numbers refer to where the illustrations may be found. The other page numbers refer to where the item has also been mentioned.

A DEPARTURE, 154

"A Journey Through Sunny Provence," 124

A NEW DAY, 94

A NICE PLACE TO BE, 87

A PERFECT DAY, 80, 222

"A Submarine Investigation," 138

ACROSS THE VALLEY, 92

Adlake Camera, 173; poster, 191

AFTERGLOW, 94

AGRICULTURAL LEADER'S DIGEST, 117

AIR CASTLES, 35, 156

ALADDIN AND THE WONDERFUL LAMP, 35, 135

AMERICAN ART BY AMERICAN ARTISTS, 101

AMERICAN ARTIST, 117

AMERICAN COLLECTOR, 101

AMERICAN HERITAGE, 101

AMERICAN MAGAZINE, 117

AMERICAN MAGAZINE OF ART, 117

AMERICAN MONTHLY REVIEW OF REVIEWS, 117

AMERICAN PICTURES AND THEIR PAINTERS, 101

American Water Color Society Poster, 191

AN ANCIENT TREE, 83, 222

AN ODD ANGLE OF THE ISLE, 57

AND NIGHT IS FLED, 69, 117, 158, 186; playing cards, 248

ANNUAL OF ADVERTISING ART IN THE UNITED STATES, 101

ANTIQUE TRADER, 118

ANTIQUES, 118

"April," 142

"April Showers," 138

ARABIAN NIGHTS, book, 102; illustrations from, 101, 168, 170, 242

ARCHITECTURAL LEAGUE OF NEW YORK YEARBOOK, 118

ARCHITECTURAL RECORD, 118

"Arithmetic," 143

"Arizona," 160, 229; thermometer, 253

ART INTERCHANGE, 119

ART JOURNAL, 119

"Artist," 138; male, 138

ARTIST, magazine, 119

ARTS AND DECORATION, 119

AS MORNING STEALS UPON THE NIGHT. 86

"At An Amatuer Pantomine," 177

AT CLOSE OF DAY, 91, 96; greeting card, 241

ATLANTIC MONTHLY, 119

ATLAS, 35, 136

AUCASSIN SEEKS FOR NICOLETTE, 36, 181

AUTUMN, **36**, **130** AUTUMN BROOK, **78**

"Balloon Man," 138

"Be My Valentine," 117

BELLEROPHON, 38, 138

Bicyclist, female, 150, 193; male, 150, 192

Blotter, 235

"Boar's Head," 130

BOBOLI GARDEN, 62

BOLANYO, 102

BOOK BUYER, 119, 120

BOOKLOVER, 45, 141

BOOKMAN, 120

Book Matches, 235

BOOK NEWS, 120, 121

"Botanist," 136

BRADLEY, HIS BOOK, 121

BRAZEN BOATMAN, THE LANDING OF, 36, 136, 225

BROADMOOR HOTEL, 37, 147, 159, 175; book matches, 235;

lipstick tissue, 247; menu, 247; postcard, 250; room card, 252; playing cards, 249; tin lid, 255

Brown & Bigelow miscellaneous calendars, 222; playing cards, 248, 249

BRUSH AND PENCIL, 121

Bryn Mawr College Theatrical Program Cover, 210

"Buds Below the Roses," 157, 174

Business Cards, 235

Business Man's Calendars, 223, 225, 226, 228

CADMUS SOWING THE DRAGON'S TEETH, 37, 137,226

Calendar of Cheer, 223, 227, 228

Calendar of Friendship, 223, 225, 226, 227, 228

Calendar of Kipling's Ballads, 232

Calendar of Sunshine, 223, 225, 227

"Call to Joy," 157; triptych, 257

CANADIAN HOME AND GARDEN, 121

CANYON, 37

"Cardinal Archbishop," 181

CASCADES, 87

CASSIM IN THE CAVE, 38, 133, 168, 251

"Castle of Indolence," 221

CENTAUR, 38

CENTURY MAGAZINE, 121-127; poster, 191, 192

"Child Harvester," poster, 201

CHILDREN'S BOOK, 102

CHIMERA, 38, 138

Chocolate Boxes, 236

CHRISTIAN HERALD, 127

CHRISTMAS, **59**, **161**

CHRISTMAS EVE, 93

"Christmas Life," 164, 167

"Christmas MDCCCXCVI," 147

CHRISTMAS MORNING, 93

CHURCH AT NORWICH, 95

"Church, Norwich, Vermont," 188

Cigar box, 237

Cigar box label, 237

"Cinderella," 147

CIRCE'S PALACE, 39, 136, 227

CITY OF BRASS, 39, 135, 168

CLEOPATRA, 40; chocolate box, 236

Colgate and Company Poster, 192; calendar, 232

COLLIER, P.F. & SON, headpieces, 219

COLLIER'S MAGAZINE, 124-146; poster, 192

Columbia Bicycles Poster, 192, 193

"Comic Scottish Soldier," 142

Comical Toy Soldiers Game, 239

Community Plate, 148, 159, 174

CONTENTMENT, 72; playing cards, 248

Contentment Calendar, 224-226, 228

Copeland and Day Publishers poster, 193

COSMOPOLITAN MAGAZINE, 146

COUNTRY LIFE, 146

"Courage," 141

Crane's Chocolates, boxes, 236; tin sign, 255

CRITIC, 146

"Dark Futurist," 167

DAWN, 69

DAYBREAK, 40, 83, 97, 118, 119, 222; jigsaw puzzle, 242

DEEP VALLEY, 93

DELINEATOR, 147

"Desert," 181

Desk Easel Calendars, 228

"Dies Irae," 153, 154

DINGLETON FARM, 97

DINKEY-BIRD, 40, 154, 251

Djer-Kiss, 117, 147, 158, 159; sheet music, 252; window display, 193; calendar, 232

Dodge Publishing miscellaneous calendars, 223, 232

"Dream Castle in the Sky," 125

DREAM DAYS, 102; illustrations from, 153, 154

DREAM GARDEN, 41, 158; pamphlet, 210

DREAMING, 41, 229; thermometer, 254; triptych, 256

DREAMLIGHT, 71

Dutch Boy, 192, 232

EARLY AUTUMN, 78

EARLY YEARS, 108

EASTER, 41, 128, 168

ECSTASY, 73; playing cards, 248

Edison Mazda advertisement, 174, 175; blotter, 235;

book matches, 235; calendar, 232; counter display, 197, 198;

hanging sign, 252; lamp booklet, 244; lamp display, 244, 245;

letter seal, 246; life-size advertisement, 199; light bulb tin, 239; playing cards, 248; tape measure, 253; window dislpay, 198

EGYPT, 70; playing cards, 248

EMERALD STORY BOOK, 103

ENCHANTMENT, 71; playing cards, 248

"End," 144

ERRANT PAN, 42, 183

EVENING, 42, 81, 96, 164, 222

EVENING SHADOWS, 78, 83, 98, 222

EVENTIDE, 92

"Every Plunge of Our Bows Brought Us," 153

EVERYBODY'S MAGAZINE, 147

Exhibition of Paintings pamphlet, 210

FARMER'S WIFE, 147

"Father Knickerbocker," 117

"Father Time," 128

Ferry, D.M. Company catalog, **211**; poster, **193**, **194**; seed advertisements, 127, 186, 188

Film/video cassette, "Parrish Blue," 238

"Finest Song," 170

First Exhibition of Original Works advertising handout, 195

"Fisherman," 164

FISHERMAN AND THE GENIE, HISTORY OF THE, 44, 132, 136, 168, 251

Fisk Rubber Company advertisements, 117, 162, 168, 174; wallpaper frieze, **197**; window display, **196 197**

"Fit for a King," 162, 168, 174; window display, 196

Florentine Fete, 117, 118, 126, 154, **156**, 157, 159, 168, **174**, **175**, **221**; triptych, **257**

"Fly-Away Horse," 173

FOUNTAIN OF PIRENE, 42, 228

"Fourth of July", 148

FREE TO SERVE, 103, 193

FREEMAN FARM, 97

"Frog-Prince," 152

"Funnygraph," 136

Games, 238, 239

GARDEN OF ALLAH, 43; chocolate box, 236; jigsaw puzzle, 243

GARDEN OF ISOLA BELLA, 62

GARDEN OF OPPORTUNITY, 43, 157; triptych, 257

GARDEN OF YEARS AND OTHER POEMS, 103

GARDENER, 43, 133, 188

General Electric, counter display, 197, 198; doll, 256; life-size advertisement, 199; window display, 198

Genesee Pure Food Company standup advertisement, 200

Gesso and wood wall plaque, 241

"Get the Habit," 253

GLEN, 77

GLEN MILL, 84

GOLDEN AGE, 104; illustration from, 154

GOLDEN HOURS, 72, 229; thermometer, 254

GOLDEN REVERIES, 52

GOLDEN TREASURY OF SONGS AND LYRICS, 104, 228

GOOD HOUSEKEEPING, 147

"Good Mixer," 169

GRAPHIC ARTS AND CRAFTS YEARBOOK, 1044

"Great Southwest," 123

Greeting Cards, 241

"Growth of the Blood Thirst," 147

"Happy New Year Prosperity," 170

HARPER'S BAZAR, 147

HARPER'S MONTHLY MAGAZINE, 147, 148

HARPER'S ROUND TABLE, 148, 149

HARPER'S WEEKLY, 149-152; poster, 200

HARPER'S YOUNG PEOPLE, 152

HARVEST, 44, 129, 223, 227

Haverford College cover, 212; poster, 201

"He is a rogue indeed who...," 166

Headpieces, 220

HEARST'S MAGAZINE, 152, 153

Heliotype Printing Company poster, 201

"Her Window," 166

"Hermes," 152

HIAWATHA, 129

"Hill Prayer," 122

HILL TOP, 230

HILLTOP, 44

Hires, Charles E. Company window display, 202;

root beer advertisements, 117, 119, 127, 186

"His Christmas Dinner," 151

HISTORY AND IDEALS OF AMERICAN ART, 104

HISTORY OF THE FISHERMAN, 44, 251

HOMESTEAD, 84

Hornby's Oatmeal poster, 202

HOUSE AND GARDEN, 153

HOUSE BEAUTIFUL, 153

Howard Hart Player program cover, 212

"Humpty Dumpty," **163**, 173

HUNT FARM, 83

"I Am Sick of Being a Princess," 124

IDIOT, 45, 141

ILLUSTRATED LONDON NEWS, 153, 154

"In the Mountains" playing cards, 248

INDEPENDENT, 154

INTERLUDE, 45; triptych, 256

INTERNATIONAL STUDIO, 154

Irrigation Canal, poster, 192

"It Was Easy To Transport Yourself," 153, 154

ITALIAN VILLAS AND THEIR GARDENS - BOOK, 105;

illustrations from, 123; print portfolio, 250 ITALIAN VILLAS AND THEIR GARDENS - PRINTS, **62-66**, 250 "Its Walls Were as of Jasper," 154, 177

"Jack and the Beanstalk," poster, 194

JACK FROST, 45, 146

"Jack Horner," 121

"Jack Sprat," 159; poster, 205

"Jack the Giant Killer," 152

JAMA - The Journal of the American Medical Association, 155

JANION'S MAPLE, 86

"Jason and Argo," 154

JASON AND HIS TEACHER, 38, 140

JASON AND THE TALKING OAK, 46, 225, 228

Jello advertisements, 119, 147, 153, 168, 170, 173, 184, 186,

188, 200; package, 242; standup advertisement, 200

Jigsaw puzzles, 242, 243

JUNE SKIES, 80

JUNIOR CLASSICS, vol. II, 105; vol. III, 105

KING ALBERT'S BOOK, 106

"King and Queen," 119, 147, 153, 168, 170, **184**, **200**; Jello gelatin package **242** KING OF THE BLACK ISLES, **46**, 135, 168, 251

KNAVE OF HEARTS, 106; jigsaw puzzle, 243

"Knave Watches Violetta Depart," 145; jigsaw puzzle, 243

KNICKERBOCKER'S HISTORY OF NEW YORK, 106; illustration from, 146; poster, 204

"Komical Soldier," jigsaw puzzle, 243

LADIES' HOME JOURNAL, 155-161; subscription gift, 244

"Lady Violetta and the Knave," jigsaw puzzle, 243

Lamp display and tester, 244, 245

LAMP SELLER OF BAGDAD, 70; playing cards, 248

LAND OF MAKE-BELIEVE, 46, 183, 226, 228

LAND OF SCENIC SPLENDOR, 170

LANTERN BEARERS, 47, 142, 223, 228

"Lazy Land," 156

Letter seal, 246

LIFE, 161-169

Light bulb tin, 246

LIGHTS OF HOME, 92

LIGHTS OF WELCOME, 94

Lipstick tissue, 247

LITERARY DIGEST, 168

LITTLE BROOK FARM, 81

"Little Peach," 155

LITTLE STONE HOUSE, 86

"Lone Fisherman," 138

"Love's Pilgrimage," 156; triptych, 257

LULL BROOK, 93

LURE OF THE GARDEN, 107

LUTE PLAYERS, 47

MAGAZINE OF LIGHT, 168

"Magic Circle," 122; window display, 196

Make Believe World of Sue Lewin, 107

"Man in the Moon," 121

"Man of Letters," 165

"Man with Green Apple," 142

"Mary Mary" poster, 194

"Mask and Pierrot," 138

Mask and Wig Club, 121; program cover, 213

"Masquerade," 167

Masterpieces, 222

MAXFIELD PARRISH, 108

MAXFIELD PARRISH, EARLY YEARS, 108; Japanese version, 109

MAXFIELD PARRISH FOUR BEST PAINTINGS, 251

MAXFIELD PARRISH IN THE BEGINNING, 109

MAXFIELD PARRISH POSTER BOOK, 110

MAXFIELD PARRISH PRINTS, 110

Maxfield Parrish Soldier Game. 238

Maxwell House Coffee, 147, 159, 175

McCALL'S, 168

McCLURE'S, 168

MENTOR, 168, 170

Menu, 247

"Merry Christmas," 163

METROPOLITAN MAGAZINE, 170

Midsummer Holiday Number, 146, 191

"Milking Time," 132

MILL POND, 82, 222

MISTY MORN, 84

MODERN ILLUSTRATING, 110

"Modern Magic Shoes," 162, 196

MODERN PRISCILLA, 170

MOONLIGHT, 74

MORNING, 47, 165

MORNING LIGHT, 86

"Mother Goose," 146; window display, 197

MOTHER GOOSE IN PROSE, 111; illustrations from, 154

MURAL PAINTING IN AMERICA, 111

Murphy, Thomas D., miscellaneous calendars, 229-230;

thermometers, 253, 254

My Homeland, 222

NATIONAL AUTHORITY ON AMATUER SPORT, poster, 200

NATION'S BUSINESS, 170

NATURE LOVER, 48

NEW BOOKS FOR THE HOLIDAYS, Scribner's catalog, 209

NEW ENGLAND HOMESTEAD, 170

"New Hampshire," poster, 202

NEW HAMPSHIRE: THE LAND OF SCENIC SPLENDOR, 80

New Hampshire Planning and Development Commission

posters, 202, 203

NEW HAMPSHIRE TROUBADOUR, 170, 171
New Hampshire Vacation Booklet Advertisement, 202
NEW MOON, 86, 222; playing cards, 249
NEWSWEEK, 171
"No Gentleman of France," program cover, 213
No-To-Bac poster, 203
NORWICH, VERMONT, 96
Novelty Bazaar Company poster, 203

"Ode to Autumn," 124

"Oklahoma Comes In," 136
OLD BIRCH TREE, 78
OLD GLEN MILL, 84
OLD KING COLE, 48, 118, 138, 154, 171, 173; cigar box, 237; post card, 249; tie rack, 254; tobacco package, 255; tobacco tin, 255
OLD MILL, 80
"Old Romance," 182
"On To the Garden Wall," 154
"Once Upon A Time," 170
Only God Can Make a Tree, 229

PAGE, 48; jigsaw puzzle, 243
Painter's palette, 258
PANDORA, 49, 140, 231
Parker Brothers Games, 238-240
"Parrish Blue" video, 238
PATH TO HOME, 92
PEACE AT TWILIGHT, 93
PEACE OF EVENING, 83, 97
PEACEFUL COUNTRY, 88
PEACEFUL NIGHT, 95
PEACEFUL VALLEY, 77, 84, 222
PENCIL POINTS, 173
"Penmanship," 141

Our Beautiful America, 222 OUTING, 171, 172 OUTLOOK, 173

Pennsylvania Academy of the Fine Arts poster, 203; program, 213
Pennsylvania State College class book, 213
"Peter, Peter," 127, 188; poster, 193
"Peter Piper," 186; poster, 194
PETERKIN, 111

Philadelphia Bourse catalog cover, 213
Philadelphia Horse Show Association poster, **204**; illustration of, 121

"Philosopher," **143**"Phoebus on Halzaphron," 178
PHOENIX THRONE, **57**PICTORAL REVIEW, 173
PIED PIPER, **49**; post card, **249**

PIERROT'S SERENADE, 49, 136

"Pipe Night at the Players," 126

"Pirate," 139

PLAINFIELD N.H. CHURCH AT DUSK, 91

Playing cards, 248, 249; canasta, 249

POEMS OF CHILDHOOD, 111

"Polly Put the Kettle On," 153, 173, **186**, 188; Jello gelatin package, **242**

POOL OF VILLA D'ESTE, 63

Post cards, 249, 250

POSTER, 173

POSTERS: A CRITICAL STUDY, 112

POSTERS IN MINIATURE, 112

"Potato Peelers," 119

"Potpourri," 182

PRIMITIVE MAN. 70, 175

PRINCE, 50; jigsaw puzzle, 243

PRINCE AGIB, **50**, 133, 170, **226**, 228

PRINCE CODADAD, 51, 168, 226, 227, 251

Print portfolios, 250, 251

PROGRESSIVE FARMER, 173

PROMETHEUS, 69, 174

PROSERPINA, 51, 140, 231

"Prospector," 142

PROSPERO AND HIS MAGIC, 57

"Proving It by the Book," 125

"Puss-in-Boots," 153

"Quarter Staff Fight," 184

QUEEN GULNARE, 52, 135, 225, 231

QUEST FOR THE GOLDEN FLEECE, 52, 140, 228

QUIET SOLITUDE, 87

"Quod Erat Demonstrandum," 125

"Rape of the Rhine-Gold," 177

Rawhide, 168

RCA Radiotron Doll. 256

RED LETTER, 173

"Reluctant Dragon," 119, 153

REVERIES, **52**, **72**; gesso wall plaque, **241**; playing cards, 248; triptych, **256**

ROAD TO THE VALLEY, 81

Rock of Ages, 229

"Roman Road," 172

ROMANCE, 53

ROMANTIC AMERICA, 112

Room card, 252

Royal Baking Powder, 150, 177, 180

ROYAL GORGE, 53

RUBAIYAT, 53; chocolate box, 236

RUBY STORY BOOK, 112

Russell, R.H. Publishing poster, 204

"Saga of the Seas," 154

"Saint Nicholas," 120

ST. NICHOLAS, 184

"St. Patrick," 162

"St. Valentine," 162

"Sandman," 124, 184

SANTA BARBARA MUSEUM OF ART, 173

SAPPHIRE STORY BOOK, 112

SATURDAY EVENING POST, 174-176; gift certificate, 221; subscription card, 221

"School Days," 137

Scribner Books for Young Readers catalog, 214

SCRIBNER'S, 176-183; catalog, 209; poster, 204, 205

Scribner's, Charles, Sons miscellaneous calendars, 231

Scribner's New Books for the Young Catalog, 215

SEARCH FOR THE SINGING TREE, 54, 134, 223; jigsaw puzzle, 242

"Seein' Things at Night," 155

Sheet music, 252

SHELTERING OAKS, 87, 222; playing cards, 249

SHOWER OF FRAGRANCE, 54, 157

Signs, 252

"Signpainter," 140

SILENT NIGHT, 91, 92

SINBAD PLOTS AGAINST THE GIANT, 54, 135

SING A SONG OF SIXPENCE, 55, 125

"Sleeping Beauty," 153

Soldier Ten Pins Game, 240

SOLITUDE, 73

SONG OF HIAWATHA, 112

SPINNING WHEEL, 183

SPIRIT OF THE NIGHT, 69, 159; playing cards, 248

SPIRIT OF TRANSPORTATION, 55, 153, 170

SPRING, 55, 128

Stamp, 253

STARS, 56

Sterling Cycle Works catalog, 215

STORY OF A KING'S SON, 50, 231

"Story of Snowdrop," 152

SUCCESS, 185

SUCCESSFUL FARMING, 185

SUGAR-PLUM TREE, 56, 155, 173, 251

SUMMER, **56**, 129, 134, 227

SUNLIGHT, 96, 222

Sunlit Road Calendar, 225, 226, 228

SUNLIT VALLEY, 82

"Sunny Provence," 184

SUNRISE, 74, 95, 168, 229; greeting card, 241; thermometer, 254

SUNUP, 81, 222

SURVEY, 185

"Sweet Nothings," 159

Swift and Company poster, 205; ham advertisement, 159

SWIFT-WATER, 84

"Swing," 133

"Swiss Admiral," 163

Tape measure, 253

"Tea? Guess Again," 166

TEMPEST, 57, 58

"Temptation of Ezekiel," 147

THANKSGIVING, 59, 223

THEATRE AT LA PALAZZINA SIENA, 63

Thermometers, 253, 254

THIRTY FAVORITE PAINTINGS, 112

"Three Caskets," 184

THREE SHEPHERDS, 59, 127, 224

"Three Wise Men of Gotham," 120

"Thunderheads," 173

THY ROCKS AND RILLS, 80, 222

THY TEMPLED HILLS, 80, 118, 170, 222; poster, 202

THY WOODS AND TEMPLED HILLS, 230

Tie rack, 254

Tin lid, 255

Tin sign, 255

Tobaco package, 255

Tobacco tin, 255

TOPAZ STORY BOOK, 112

"Tourist," 139

Toy advertising dolls, 256

"Toyland," 137, 154, 192; poster, 206

Toy Show poster, 203

"Tramp's Thanksgiving," 130

TRANQUILITY, 77, 188

Triptychs, 256, 257

TROUBADOUR TALES, 112

TURQUOISE CUP AND THE DESERT, 112

TURQUOISE STORY BOOK, 112

"Twenty-First of October," 154

TWILIGHT, 77, 87, 222

TWILIGHT HOUR, 94

TWILIGHT TIME, 97

UNDER SUMMER SKIES, 86

VALLEY OF DIAMONDS, 59, 135

VALLEY OF ENCHANTMENT, 81

VANITY FAIR, 186

"Vaudeville," 136

VENETIAN LAMPLIGHTER, 71; playing cards, 248

"Venitian Night's Entertainment," 181

Vermont Association for Billboard Restriction poster, 206; post card, 250

"Very Little Red Riding Hood," program cover, 213

Video cassette, "Parrish Blue," 238

"Vigil-At-Arms," 182

VILLA CAMPI, 63
VILLA CHIGI, 64, 154
VILLA D'ESTE, 64
VILLA GAMBERAIA, 64
VILLA GORI, 65
VILLA ISOLA BELLA, 65
VILLA MEDICI, 65
VILLA PLINIANA, 66
VILLA SCASSI, 66
VILLAGE BROOK, 78, 222
VILLAGE CHURCH, 82

Wallpaper frieze, 197 WANAMAKER'S catalogs, 215; painter's palette, 258 WASSAIL BOWL, 60, 140, 223 WATER COLOUR RENDERING SUGGESTIONS, 112 WATERFALL, 73, 168; playing cards, 248 "Waters of Venice," 182 "Welcome Home," menu frontispiece, 247 Wellsbach Light poster, 206 West Chester Cricket Club playbill, 215 WHEN DAY IS DAWNING, 95 When Winter Comes, 230 WHIST REFERENCE BOOK, 113 WHITE BIRCH, 60, 230 "White Birch in Winter," 187 WHITE BIRCHES IN A GLOW, 95 WHITE OAK, 87, 160 WILD GEESE, 60 "Winter," 132 WINTER NIGHT, 91 "Winter Paradise," 171; poster, 203 WINTER SUNRISE, 95 WINTER SUNSHINE, 96 WINTER TWILIGHT, 91 WITH TRUMPET AND DRUM, 61, 156, 251 WOMAN'S HOME COMPANION, 186 WONDERBOOK AND TANGLEWOOD TALES, 113; illustrations from, 101 "Wond'rous Wise Man," 121, 154 WORLD'S WORK, 186 WYNKEN, BLYNKEN AND NOD, **61**, 155, 251

YANKEE, 187, 188

"Ye Royall Recepcioun," 119

YOU AND YOUR WORK, 188

"Young America Writing Declaration of Independence," 139

YOUTH'S COMPANION, 188

FROM THE AUTHOR

"That's a Parrish", the young woman said, pointing at a picture hanging in my gallery in the early 1960's.

"No, that's a barn" I said.

"It's a Parrish" she insisted.

"No it's a barn" I proclaimed.

"Maxfield Parrish is the artist and the picture is Twilight" she explained.

"Oh", I said.

That was my introduction to one of America's superstars.

With my eyes now open to the magical blue in *Stars*, *Ecstacy*, and *Misty Morn* etc., and the fantasies his art depicts, I became obsessed and sought Parrish's work everywhere.

The enchanting images of the *Frog Prince* and *Humpty Dumpty* and the subtle humor expressed by the young female *Reluctant Dragon*, added to my delight at his versatility.

In more than thirty years since, I have collected original paintings, studies, drawings, prints, calendars and the unusual such as tin signs, autograph books, signed checks, paper doll cut outs which Parrish painted for his children and much, much more.

ABOUT THE AUTHOR

Erwin Flacks was born in the Bronx, New York. He attended the Bronx High School of Science.

He served in the amphibious forces of the U.S. Navy throughout the Pacific during World War II.

At war's end he moved to California, attended Los Angeles City College and earned his B.A. Degree and teaching credentials at California State University Los Angeles. While teaching in the Los Angeles City Schools, he earned his Master's degree and several additional credentials at California State University Northridge. While studying for his PHD at the University of Southern California he served as Regional Vice President of the National Science Foundation.

His teaching career spanned 25 years, during which time, in 1963, he opened the Pick-A-Dilly Art Gallery in Sherman Oaks, California. He sold the Pick-A-Dilly in 1976.

In 1964 he established Fine Art Marketing Company which he currently operates with his wife Gail. During this time they have owned two art galleries, Sacci, Palm Desert, California and Erwin Gail Studios, Agoura Hills, California. In addition to presenting internationally known artist's, they can continue to publish, distribute and sell original paintings, prints and ephemera.

Erwin currently lives with his wife in Westlake Village, California.

New Books From Collectors Press

R.A. Fox & W.M. Thompson Identification & Price Guide

Finally you can learn the difference between two of the most commonly confused artists intoday's collecting: R.Atkinson Fox and William M. Thompson.

This extensive volume contains over 240 packed pages and 925 photographs with the prices on each page - not in the back of the book!

\$19.95 Plus \$2.50 Shipping

The Colors
Come To Life

For the first time ever, the Edison Mazda images Maxfield Parrish painted for General Electric are available as a separate and distinct body of work. Published with permission of General Electric Company, theses beautiful, oversized books are alive with the rich, luminous colors of Maxfield Parrish. \$17.50 Plus \$2.50 Shipping

Send checks to:
Collectors Press • Suite 11B
P.O. Box 230986 • Portland, OR 97281

VISA / MasterCard CALL (503) 684-3030